Welcome Weeds!

A Beginner's Guide to the Wild Garden

Kimberly Eve
aka Jaia Wise

Dedicated to
the children of the planet,
now and to come.

All of the drawings in this book were done by hand with pencil and watercolor in front of live plants and fairies. The fonts employed are Party Lettering, Palatino and Lucida.

Welcome Weeds!
Copyright © 2013 by Kimberly Eve Snyder
Printed through Create Space, 2014

copyright no. 1-925683380
All rights reserved.

ISBN- 10: 1490407723
ISBN- 13: 978-1490407722

Special Thanks to:
Susun Weed and Ash Tree Publishing,
Juliette de Bairacli Levy, Rosemary Gladstar,
Jean-Marie Guthery and Laughing Winds,
Shakur, Anja and Touchstone Farm,
Kelley Jepson, Allisande and Juniper Hill Farm,
Manou, Shellbell, Chance, and the Lazy River Ranch,
Ken, Joan, Ali and Steven Snyder,
Steve Weiss, Michael Brobowski, Timmy Sherlock,
The Daré Community, Vonnie and Paradise Village,
Jeff Kitchen, Libby and Quarry Hill,
Scott Anderson, Diana Zuckerman,
Anna Nielsen, Naomi Czekaj-Robbins
Cody Olson, Sarah Mac Donnell, Renard Thompson
Lee Freelander, Veronica and Jimmy,
The Leafys and all my green friends

This book also honors the spirits of my childhood friends,
Maria Vitale and Mary Quinn, and our dreams of Findhorn.

Walk in with me gently

To the world of wild weeds.
A place of bright magic
And wisdom, indeed.
Of flowers and bowers
Where the fairies call home.
Won't you be pleased when you
Find it's your own?

Table of Contents

Chapter One: Dandelion page 1

Chapter Two: Red Clover page 5

Chapter Three: Chickweed.............. page 9

Chapter Four: Daisy page 13

Chapter Five: Plantain page 17

Chapter Six: Yarrow page 21

Chapter Seven: Saint Johnswort page 25

Chapter Eight: Nettle page 29

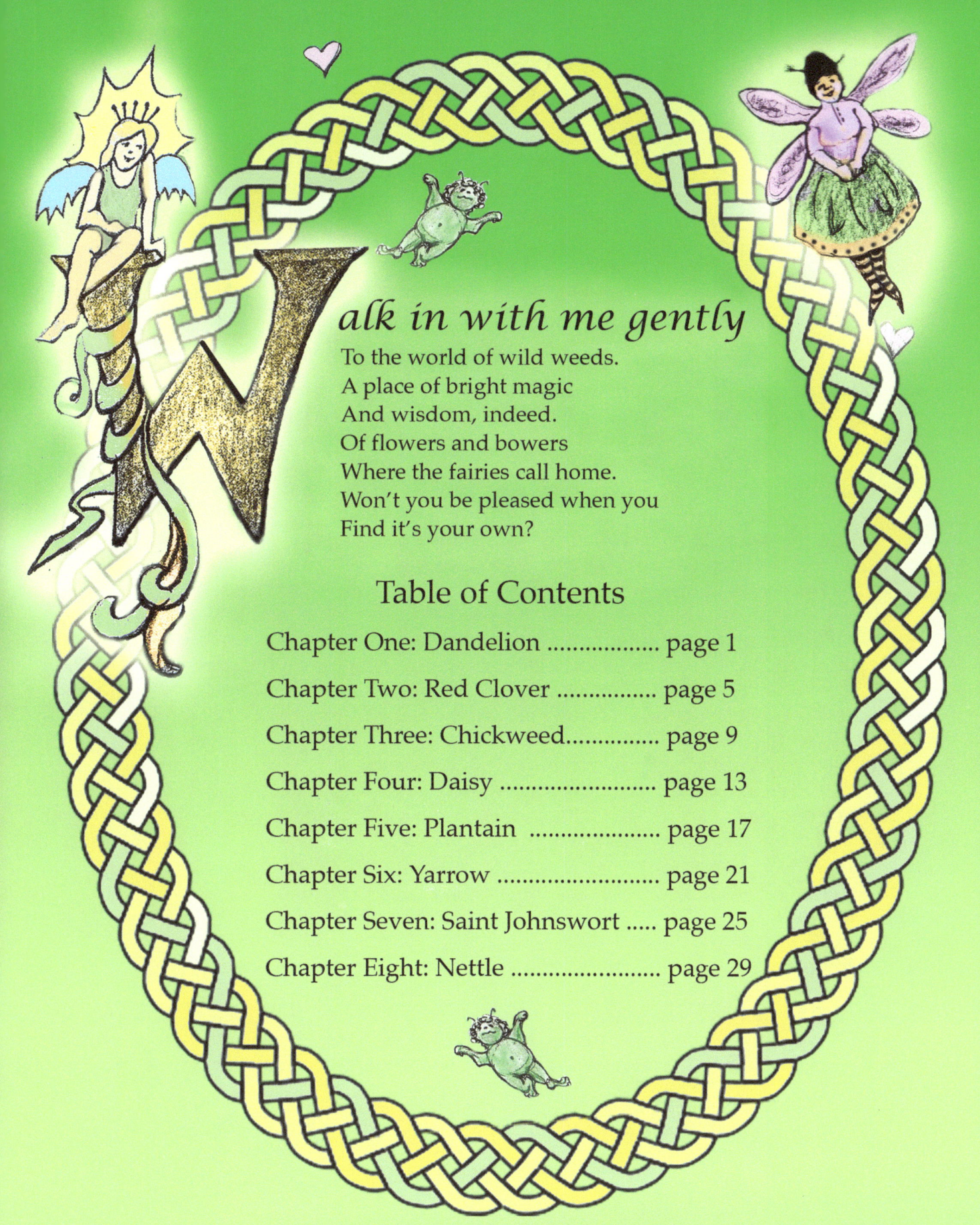

Author's Note...

When the fairies helped me write this book, they were very excited about sharing it someday with you. They were so eager to help that they even held still while posing for their portraits, and that is especially hard for most fairies. They shimmer, they flutter around and they disappear and reappear at will. A few times, they insisted that I stop everything to watch a back-flip contest or to suddenly dance around holding hands with them in a circle, but mostly, they were cooperative and willing company. Although the job left me feeling light-headed, I look forward to seeing the fairies show up, and show off more often.

This book is a "meet and greet" book, meant to introduce you to some of the most popular and wide-spread wild plants on the planet. The plants are looking forward to meeting you, too. All of the eight plants featured here have been used as food and medicine for hundreds of years. If you become interested in learning more about how to use plants, you may want to read some books on Herbalism. Herbalism is the study of plants and their uses.

The most important reason for this book is to inspire you to go outside and look more closely at nature; maybe even see and speak with fairies of your own. It is meant, at least, to open your eyes wider to the world of weeds around you so that you might grow to see them in a new, probably greener, light. Gardeners battle with weeds and view them as unwelcome pests. It's true, weeds grow fast and can take over a garden in record time. They use up soil. space and nourishment that *cultivated* plants need to thrive. Most fairies admire gardeners and would not suggest that weeds be left to go wild in a domestic garden. They only hope more people will give them the respect they deserve, and a place of their own in the yard.

Each chapter begins with the **common name** of the featured plant such as: **Dandelion**

Under that, you will see in *italics*, the **botanical name** such as: *Taraxacum officinale*. Botanical names are created so that we can be more sure of the plant we have found and that we will be less likely to confuse it with another similar plant. Botanical names are written in a language made up mostly from Greek and Latin roots.

Under the botanical name is my rough translation of that name like:
"*official remedy*"

Also included, is a list of **nicknames** for each plant.

As you read, and look at the pictures, you will discover how to better identify each plant. Grown-ups and kids will enjoy reading and exploring together. As for the fairies, they hope that you will visit them in real life soon, and in the meantime, enjoy their portraits.

Green Blessings,
Kimberly Eve
Nickname: *Jaia Wise*

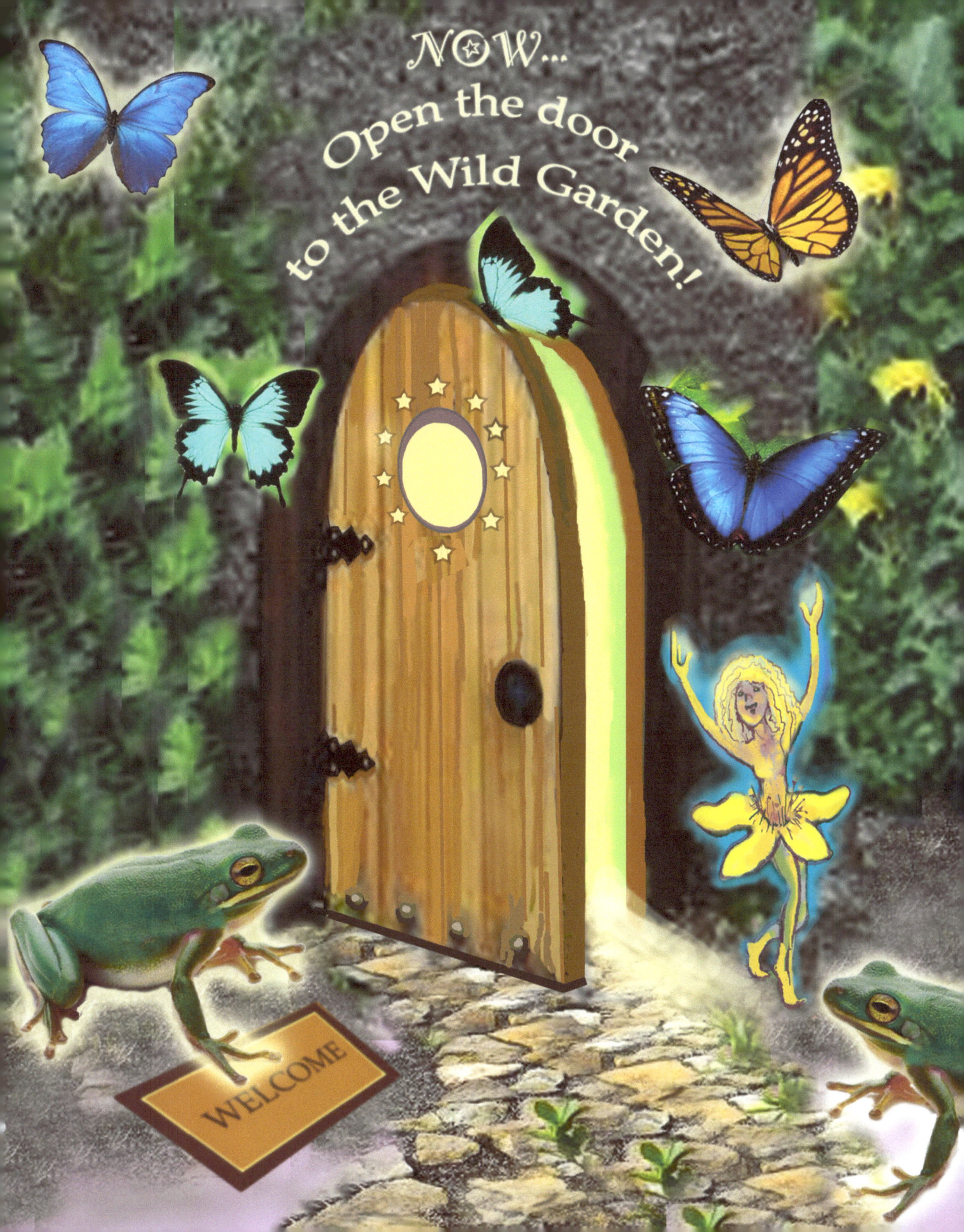

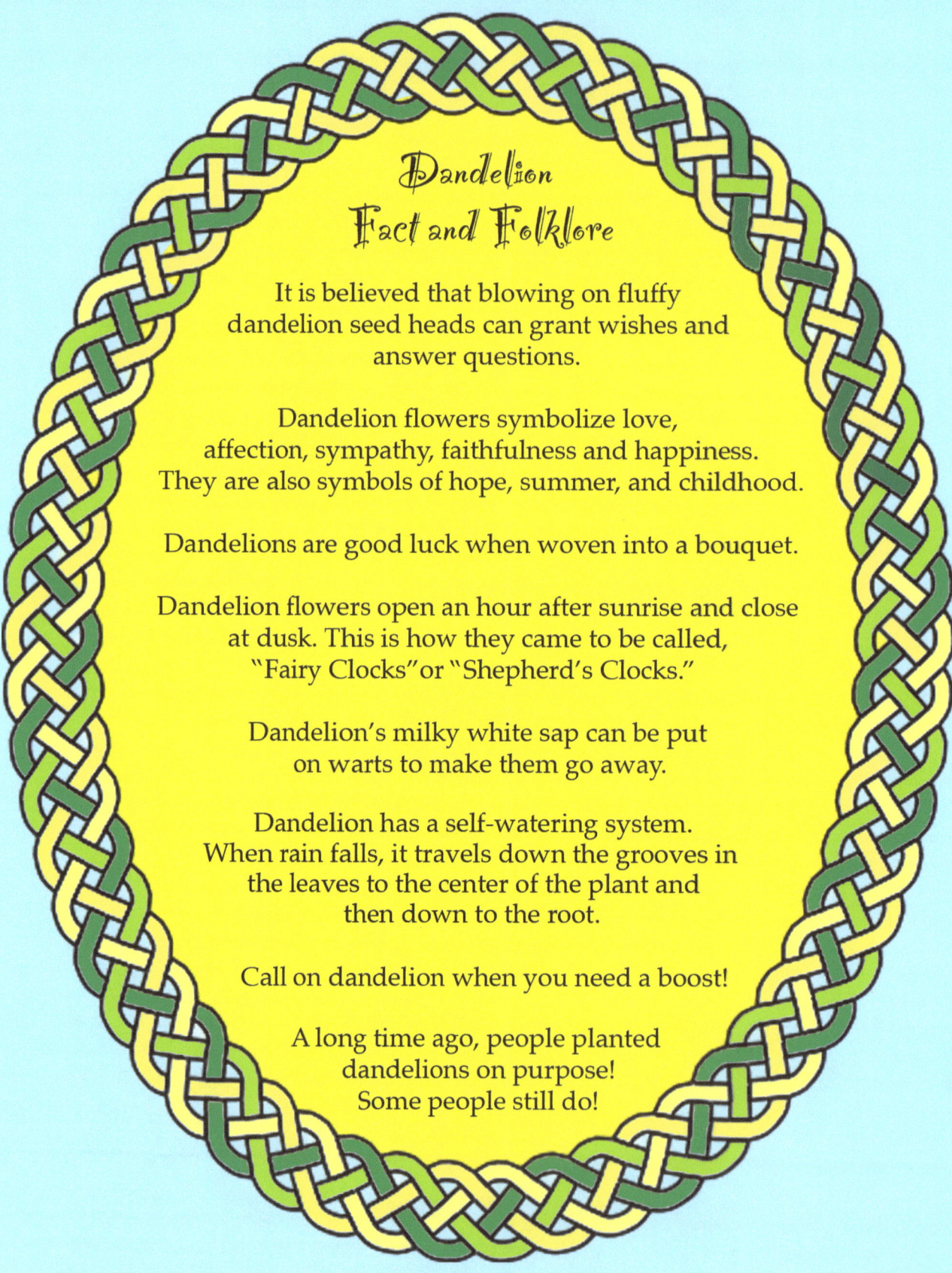

Dandelion Fact and Folklore

It is believed that blowing on fluffy dandelion seed heads can grant wishes and answer questions.

Dandelion flowers symbolize love, affection, sympathy, faithfulness and happiness. They are also symbols of hope, summer, and childhood.

Dandelions are good luck when woven into a bouquet.

Dandelion flowers open an hour after sunrise and close at dusk. This is how they came to be called, "Fairy Clocks" or "Shepherd's Clocks."

Dandelion's milky white sap can be put on warts to make them go away.

Dandelion has a self-watering system. When rain falls, it travels down the grooves in the leaves to the center of the plant and then down to the root.

Call on dandelion when you need a boost!

A long time ago, people planted dandelions on purpose! Some people still do!

Dandelion

Chapter One

Taraxacum officinale
"*official remedy*"

It isn't hard to find us,
We're growing everywhere.
A front lawn is our favorite place
To shake our yellow hair.

Before the mower finds us
And aims to mow us down,
Our flowers turn to snowy white
And spread our seeds around.

We'll admit that we are most
Proud of this timeless trick.
We want the world to get the gift
Of plenty puffs to pick.

Nicknames:
*Lion's Teeth, Fairy Clock,
Priest's Crown, Wild Endive,
Wet-a-Bed, Monks Head,
Milk Witch, Shepherd's Clock
The little plant that roars!*

The name **dandelion** comes
from the French: dent de leon
and the Spanish: diente de león
Both mean *teeth of the lion.*

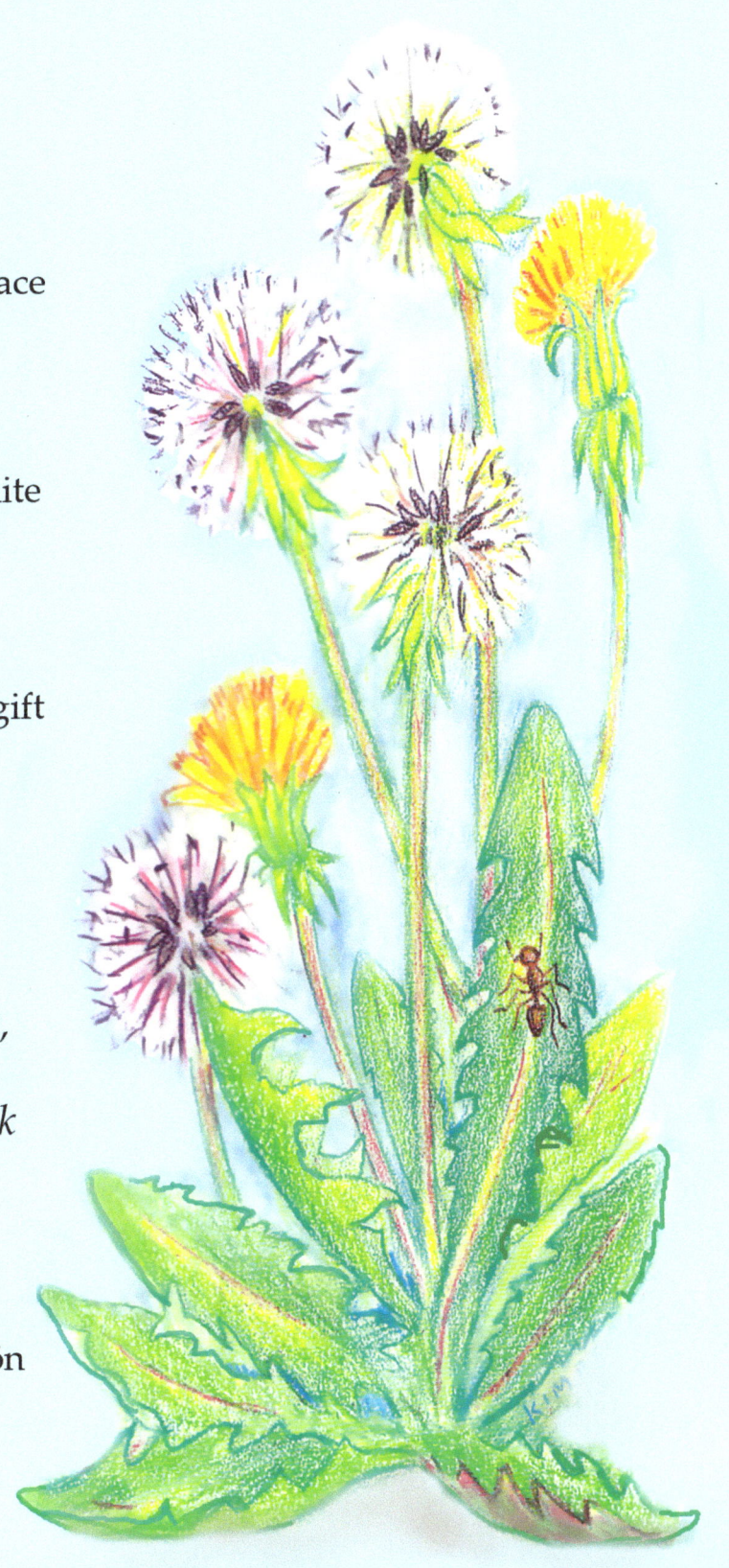

Dandelion *Taraxacum officinale*

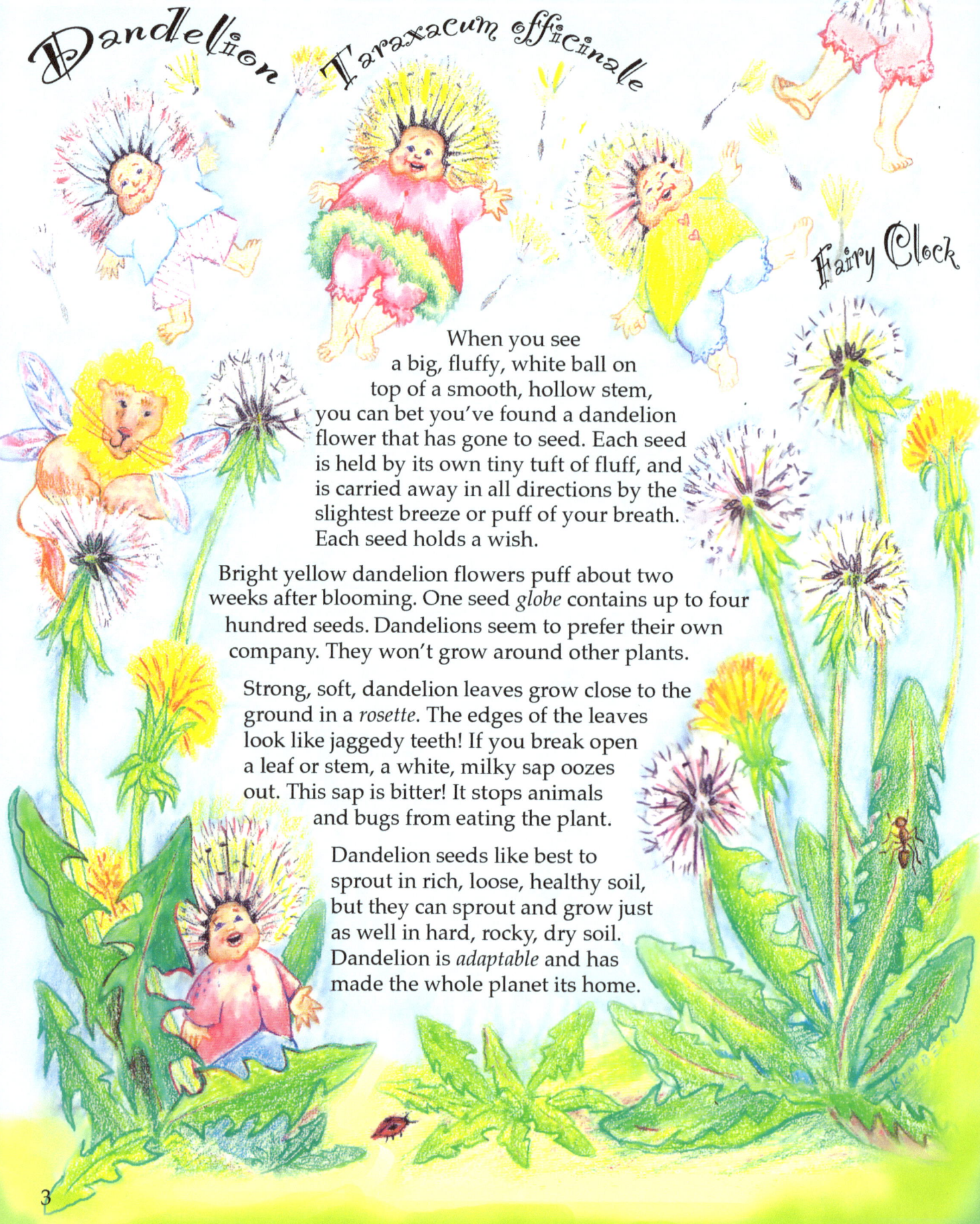

Fairy Clock

When you see a big, fluffy, white ball on top of a smooth, hollow stem, you can bet you've found a dandelion flower that has gone to seed. Each seed is held by its own tiny tuft of fluff, and is carried away in all directions by the slightest breeze or puff of your breath. Each seed holds a wish.

Bright yellow dandelion flowers puff about two weeks after blooming. One seed *globe* contains up to four hundred seeds. Dandelions seem to prefer their own company. They won't grow around other plants.

Strong, soft, dandelion leaves grow close to the ground in a *rosette*. The edges of the leaves look like jaggedy teeth! If you break open a leaf or stem, a white, milky sap oozes out. This sap is bitter! It stops animals and bugs from eating the plant.

Dandelion seeds like best to sprout in rich, loose, healthy soil, but they can sprout and grow just as well in hard, rocky, dry soil. Dandelion is *adaptable* and has made the whole planet its home.

Dandelion Fairies

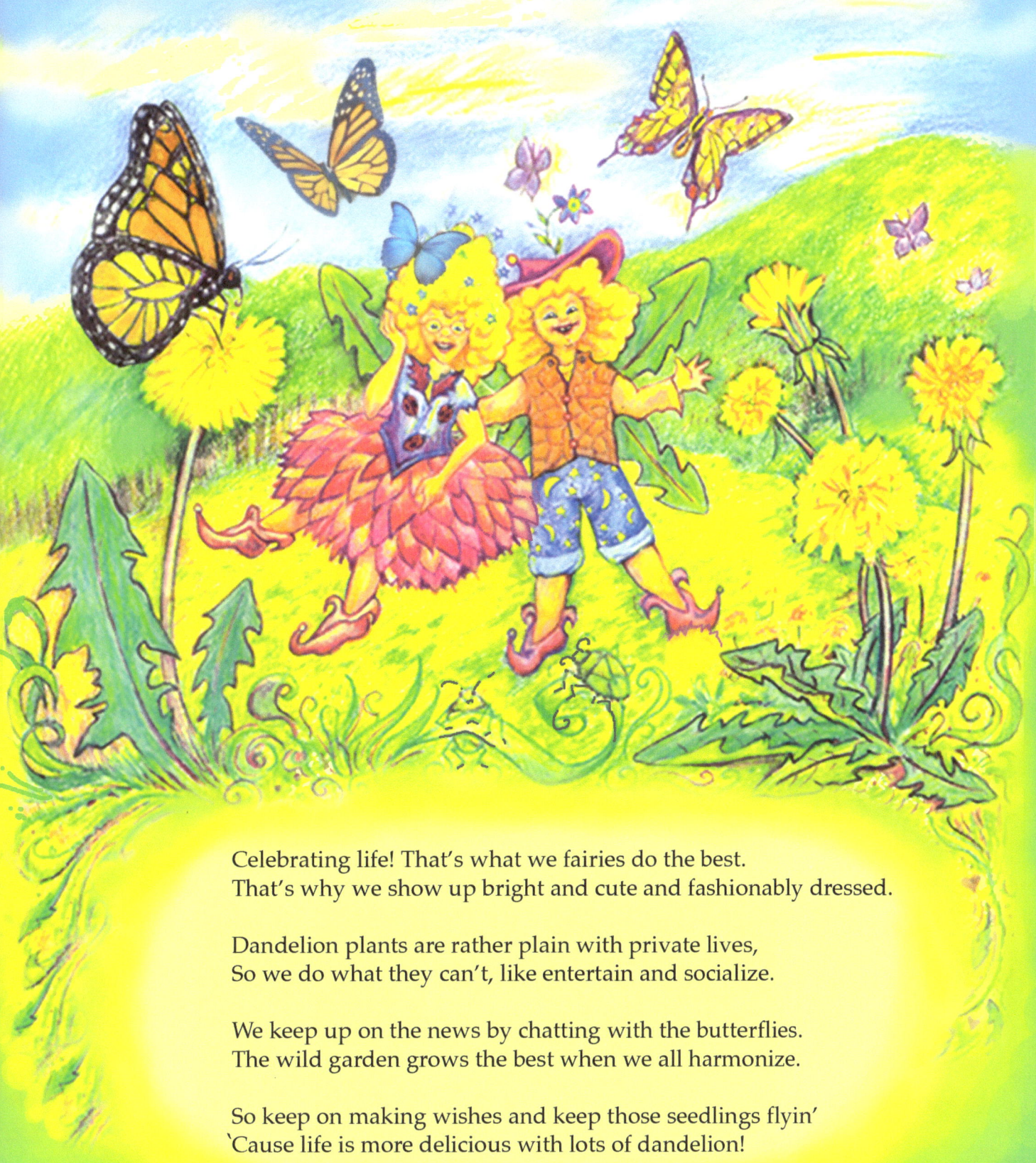

Celebrating life! That's what we fairies do the best.
That's why we show up bright and cute and fashionably dressed.

Dandelion plants are rather plain with private lives,
So we do what they can't, like entertain and socialize.

We keep up on the news by chatting with the butterflies.
The wild garden grows the best when we all harmonize.

So keep on making wishes and keep those seedlings flyin'
'Cause life is more delicious with lots of dandelion!

Red Clover Fact and Folklore

People of yore took baths in red clover tea to attract money and love.

Others used it to wash their floors and chase out unwanted ghosts.

The owner of a four-leaf clover was said to be able to see fairies and travel to the fairy realm!

This rhyme about a four-leaf clover is from the Middle Ages:

One leaf for fame
One for wealth
One for faithful love
One for glorious health

The five-leaf clover, however, was said to be unlucky.

Some people believe that washing your face in red clover morning dew will prevent freckles.

Others call freckles fairy kisses, and say that washing your face in red clover tea will make them stay!

Red Clover

Chapter Two

Trifolium pratense
"*three leaves that grow in meadows*"

We like it where the bunnies run;
Verdant valleys 'neath the sun.
All through the grass, up hill and over,
Bees sing songs among the clover.

Verdant means "very green."
Vert means "green" in French.
Verde means "green" in Italian and in Spanish.

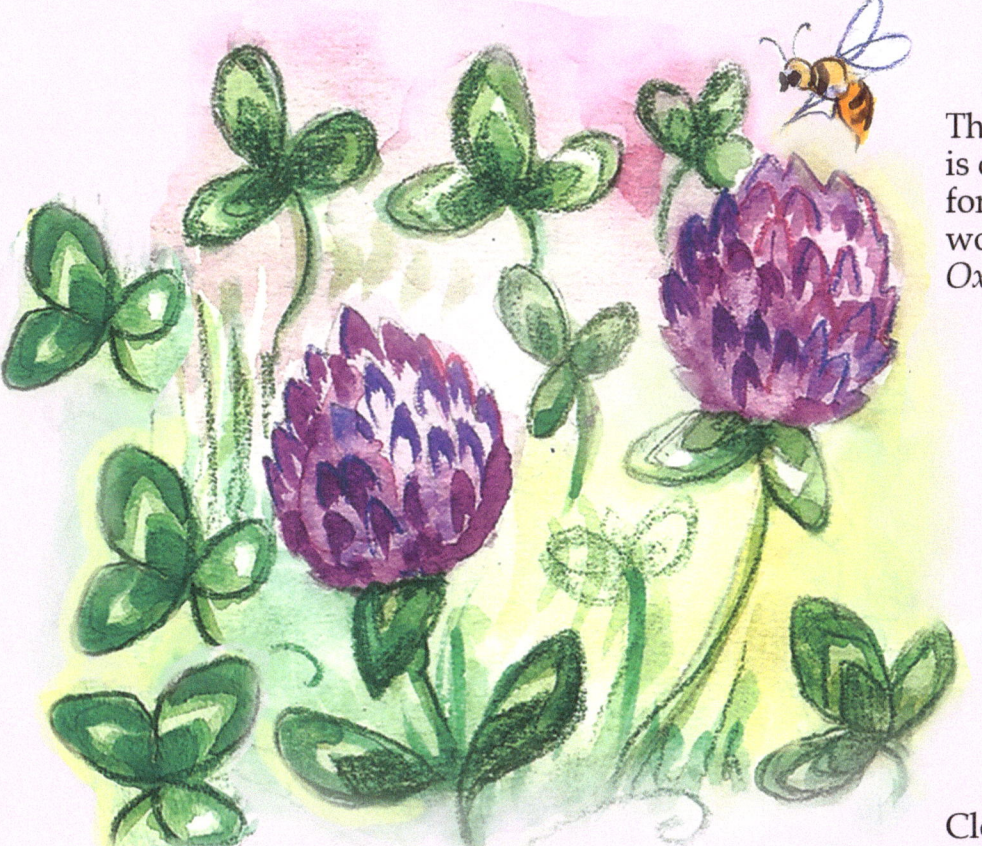

The dainty plant below is quite often mistaken for clover. It is called wood sorrel or *Oxalis Stricta*.

Clover has rounded leaves but wood sorrel has three heart-shaped leaves. They look like shamrocks!
Most types of wood sorrel have yellow or purple flowers.

Nicknames:
Honeysuckle, Purple Clover, Trefoil, Cleaver Grass, Marl Grass, Cow Grass

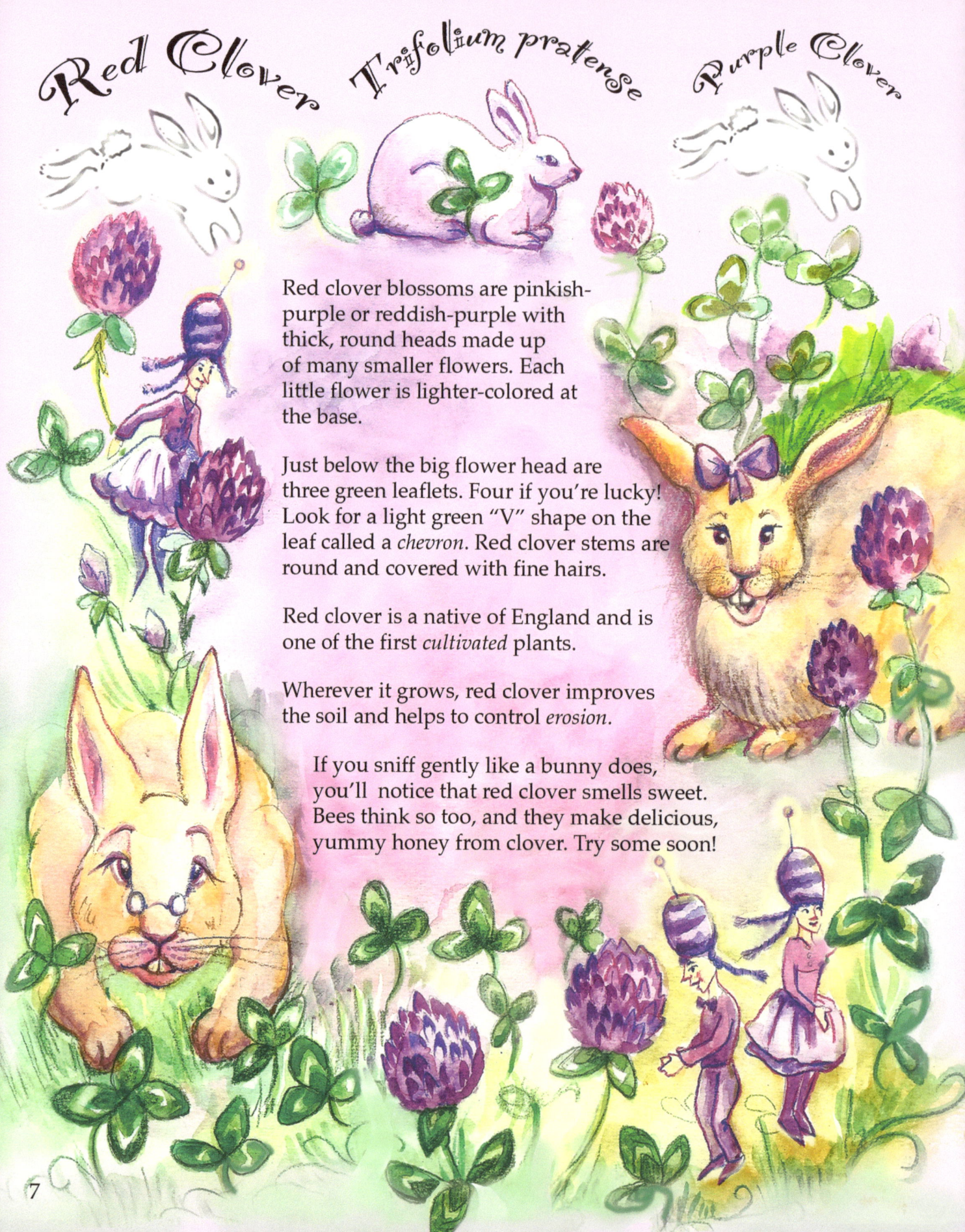

Red Clover Trifolium pratense Purple Clover

Red clover blossoms are pinkish-purple or reddish-purple with thick, round heads made up of many smaller flowers. Each little flower is lighter-colored at the base.

Just below the big flower head are three green leaflets. Four if you're lucky! Look for a light green "V" shape on the leaf called a *chevron*. Red clover stems are round and covered with fine hairs.

Red clover is a native of England and is one of the first *cultivated* plants.

Wherever it grows, red clover improves the soil and helps to control *erosion*.

If you sniff gently like a bunny does, you'll notice that red clover smells sweet. Bees think so too, and they make delicious, yummy honey from clover. Try some soon!

Red Clover Fairy Folk

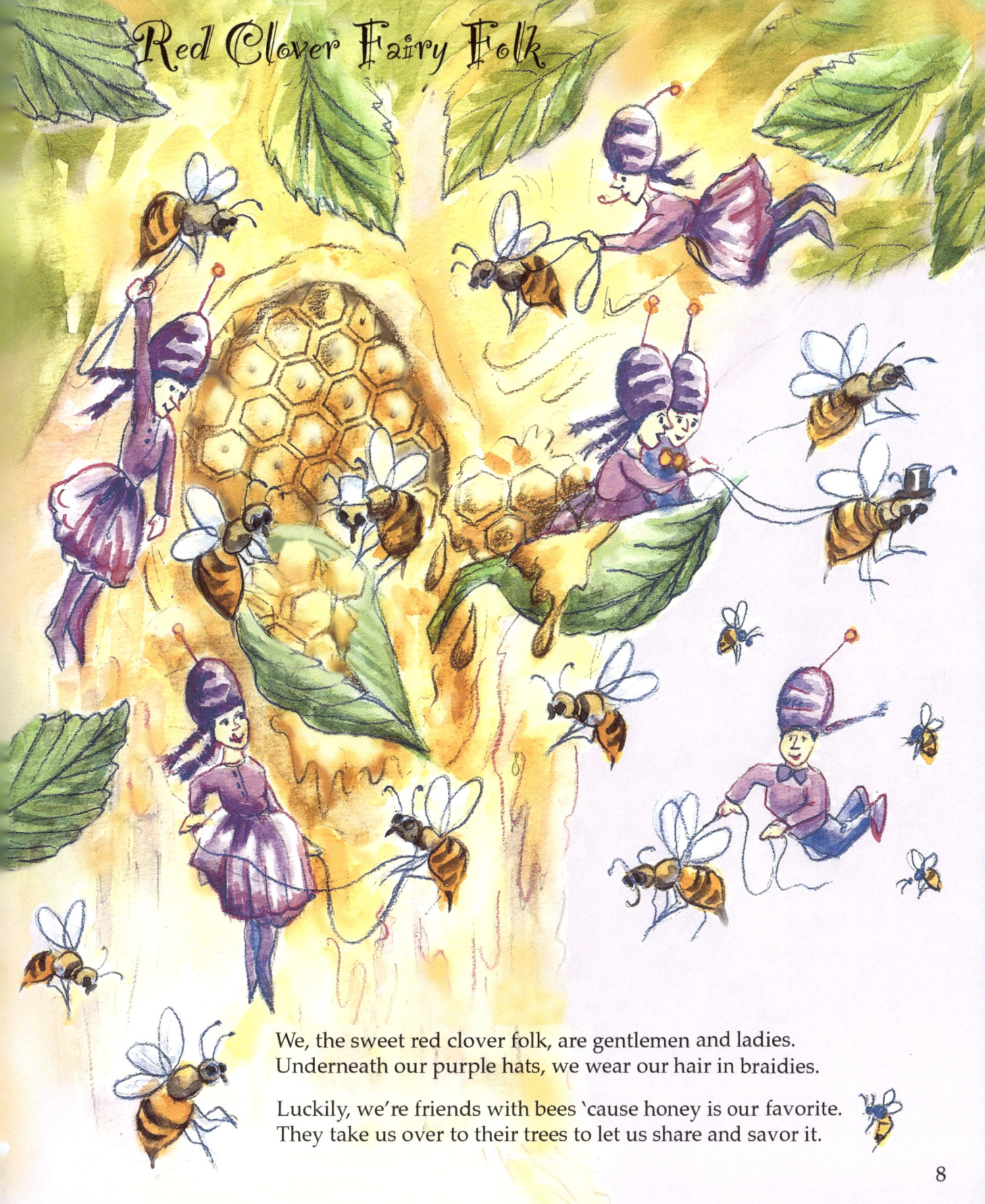

We, the sweet red clover folk, are gentlemen and ladies.
Underneath our purple hats, we wear our hair in braidies.

Luckily, we're friends with bees 'cause honey is our favorite.
They take us over to their trees to let us share and savor it.

Chickweed
Fact and Folklore

Chickweed grows in all 50 states of America.
There is no part of the world where some kind
of chickweed can't be found.

Birds everywhere, expecially young chickens,
love to eat the leaves and seeds of chickweed.
Some people also consider it a delicacy.

The creation myth of the *indigenous* Ainu people of Japan
tells us that the first humans had bodies made of earth,
hair made of chickweed,
and spines made of willow sticks!

Chickweed is good friends with the Moon
and is sometimes called the "Sleep of Plants."
This is because each night, pairs of chickweed leaves
fold together to cover tender new buds. This helps
their babies sleep safely through the night.

If you get frightened at night, call on
chickweed and the little star ladies
to bring you peaceful magic.

Chickweed

Chapter Three

Stellaria media
"little star in the midst of"

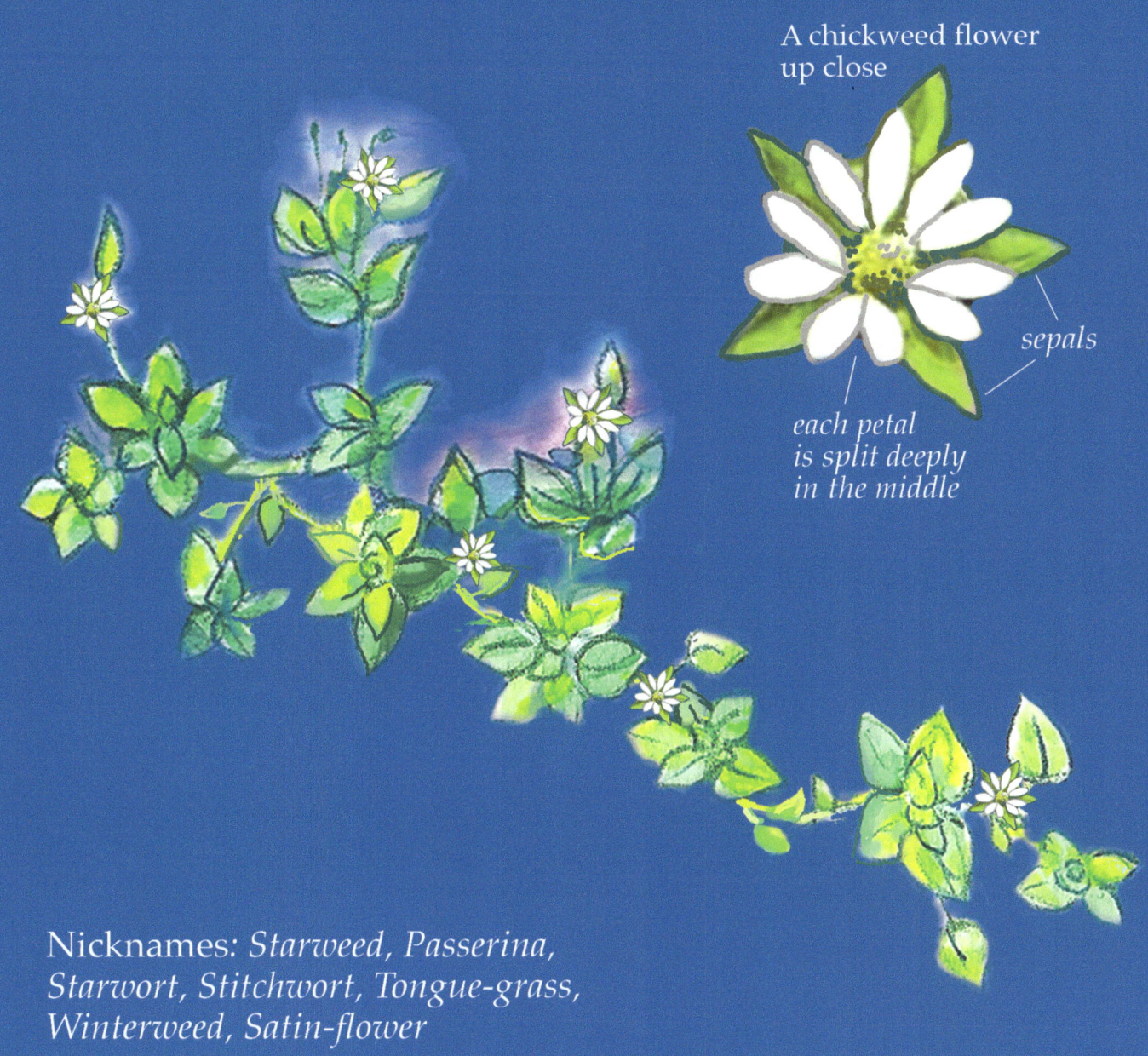

A chickweed flower up close

sepals

each petal is split deeply in the middle

Nicknames: *Starweed, Passerina, Starwort, Stitchwort, Tongue-grass, Winterweed, Satin-flower*

Chickweed *Stellaria Media* Starweed

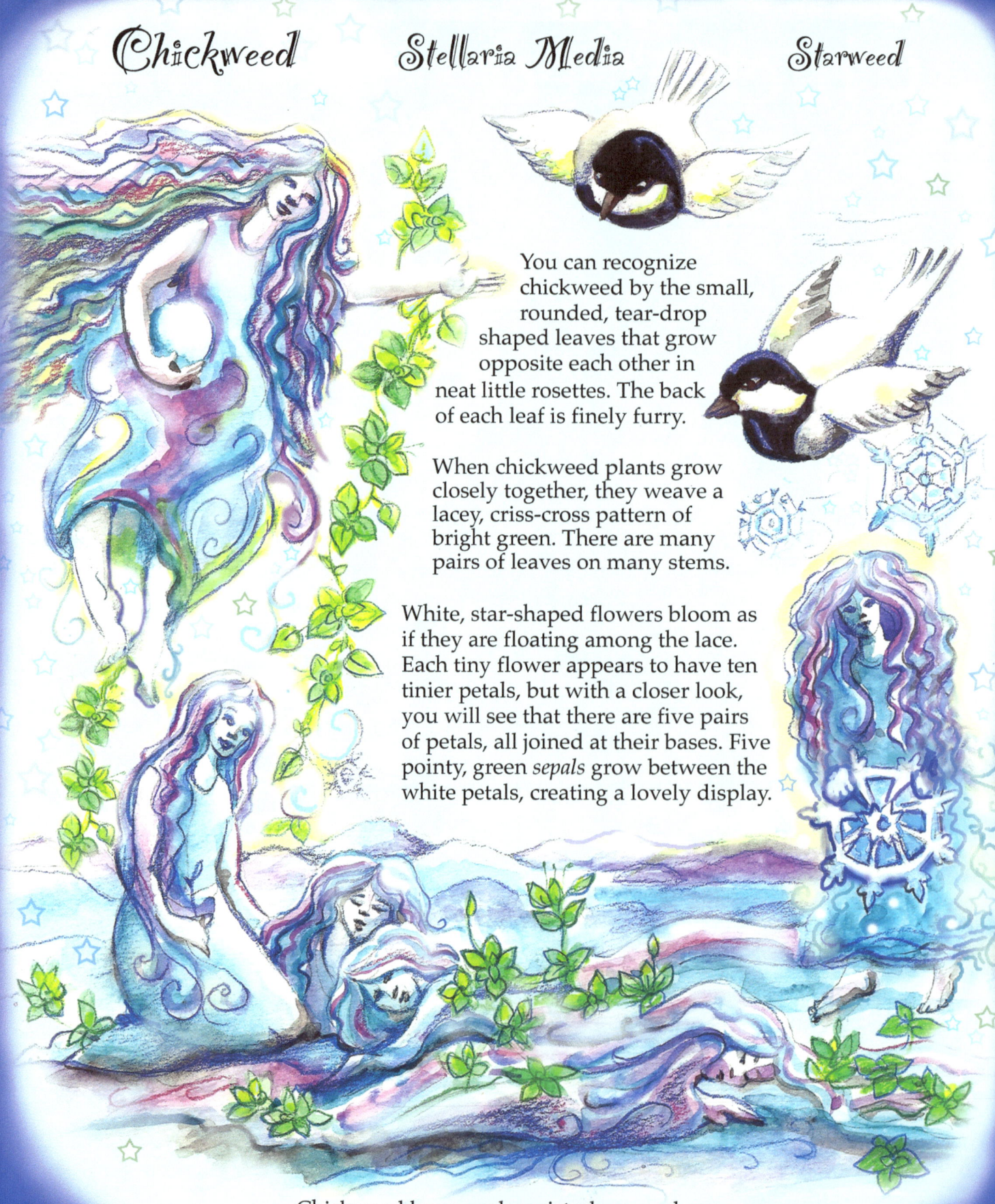

You can recognize chickweed by the small, rounded, tear-drop shaped leaves that grow opposite each other in neat little rosettes. The back of each leaf is finely furry.

When chickweed plants grow closely together, they weave a lacey, criss-cross pattern of bright green. There are many pairs of leaves on many stems.

White, star-shaped flowers bloom as if they are floating among the lace. Each tiny flower appears to have ten tinier petals, but with a closer look, you will see that there are five pairs of petals, all joined at their bases. Five pointy, green *sepals* grow between the white petals, creating a lovely display.

Chickweed loves cool, moist places and can even be found in wintertime underneath the snow.

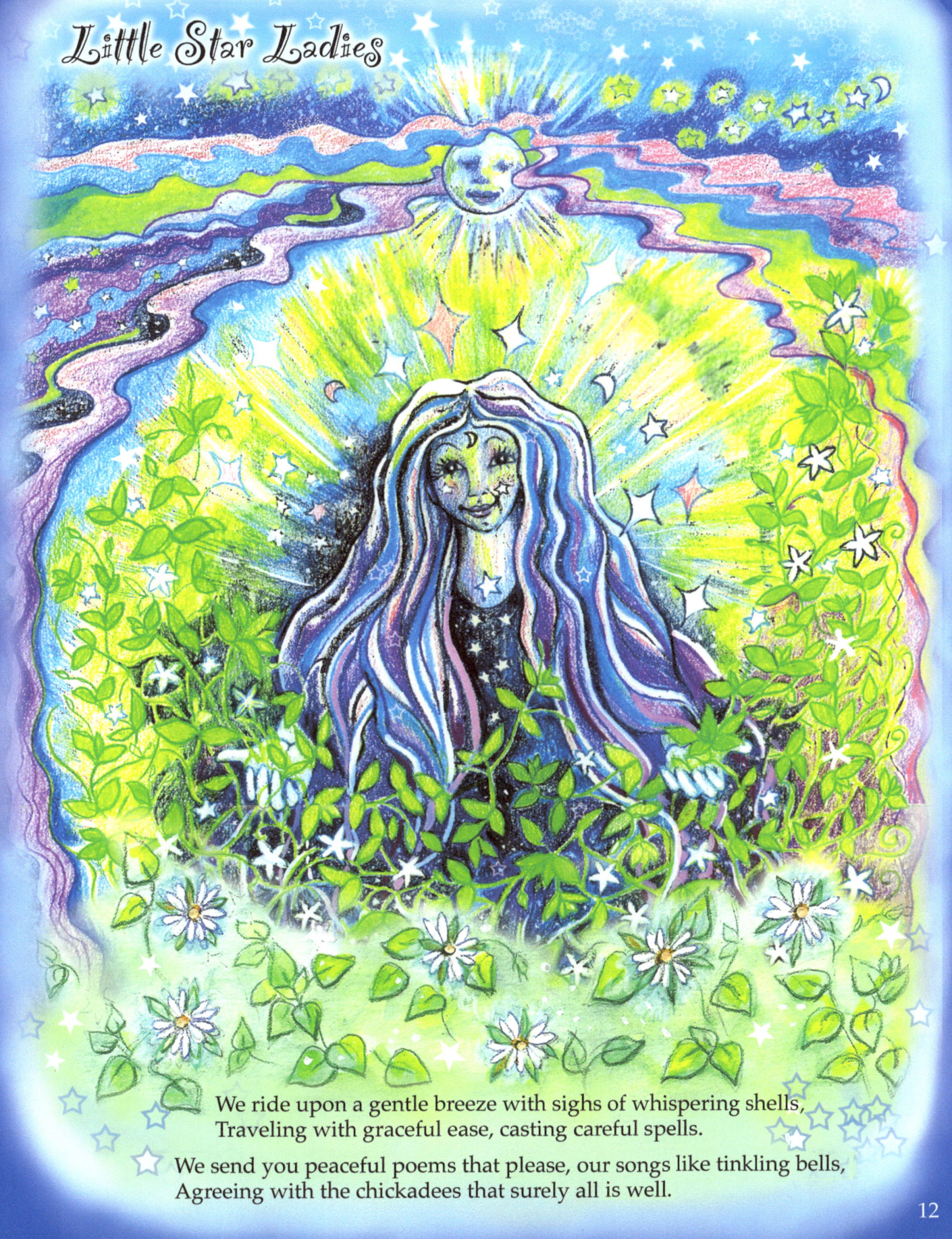

Little Star Ladies

We ride upon a gentle breeze with sighs of whispering shells,
Traveling with graceful ease, casting careful spells.

We send you peaceful poems that please, our songs like tinkling bells,
Agreeing with the chickadees that surely all is well.

Daisy Fact and Folklore

Wizards say that this little flower has
the power to ward off lightning.

Call on daisy if you are afraid
in a thunder storm.

Daisy symbolizes purity, innocence,
loyal love, beauty, patience
and simplicity.

Hairpins decorated with carved daisies were found in
the ancient Minoan palace on the island of Crete.

Egyptian vases have been found
decorated with painted daisies.

In Victorian times, it was said that if you stepped
on seven daisies at once, summer had arrived.

The name daisy comes from the
Old English dægeseage which means
days eye.

Wearing daisy chains
protects children
from harm.

Ox-eye Daisy

Leucanthemum vulgare

"gold flower, white flower"

previously:
Chrysanthemum leucanthemum

Chapter Four

According to a little rhyme,
I speak of love just half the time.
So here I made a little shift.
Now every petal is a gift.

And if you say,
"You, I adore,"
Then I will say,
"I love you more!"

Nicknames:
*Peek-a-boos,
Priest's Collar,
Moonflower,
Moon Penny,
Poverty Weed*

Ox-eye Daisy

Leucanthemum vulgare Day's Eye

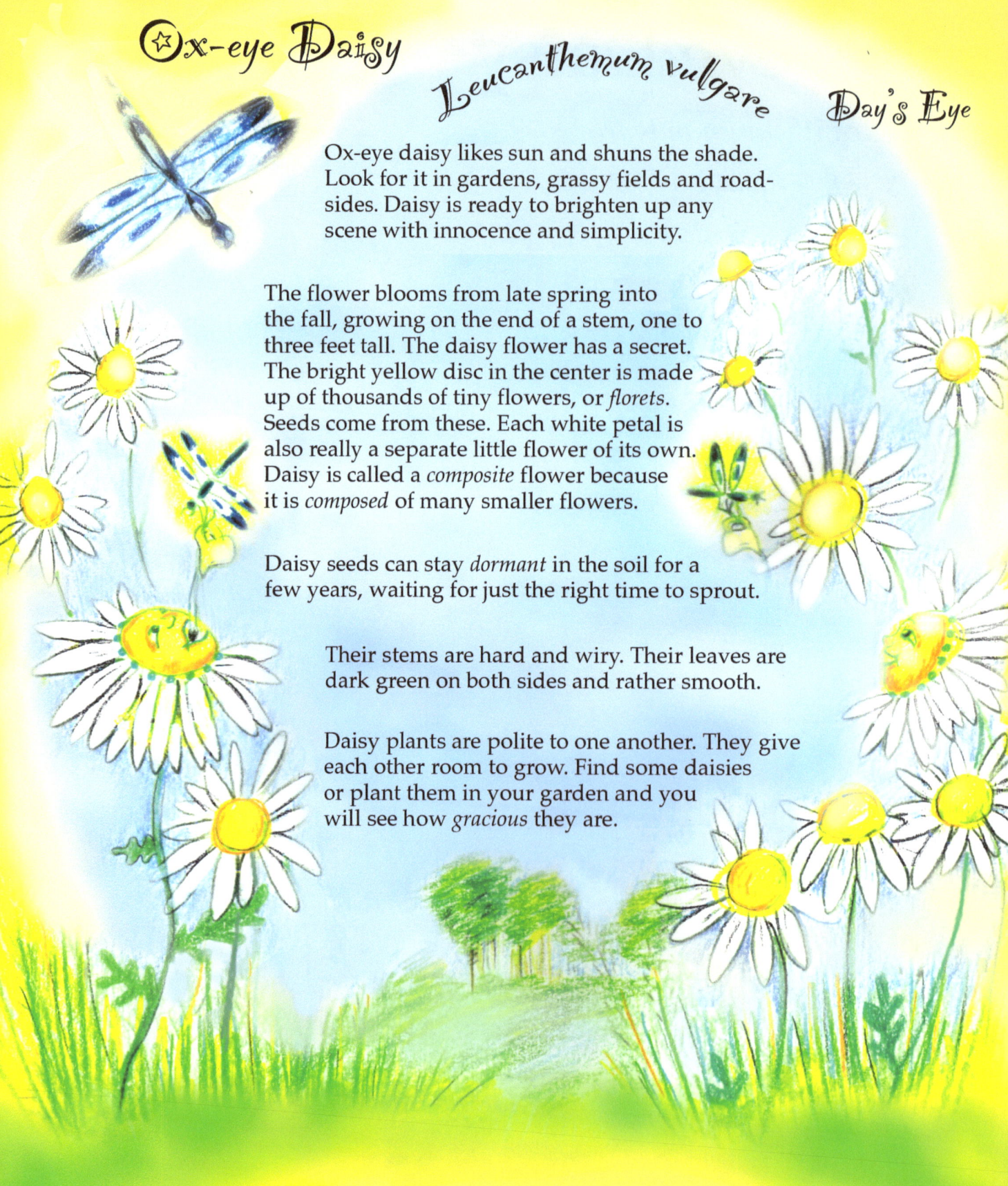

Ox-eye daisy likes sun and shuns the shade. Look for it in gardens, grassy fields and roadsides. Daisy is ready to brighten up any scene with innocence and simplicity.

The flower blooms from late spring into the fall, growing on the end of a stem, one to three feet tall. The daisy flower has a secret. The bright yellow disc in the center is made up of thousands of tiny flowers, or *florets*. Seeds come from these. Each white petal is also really a separate little flower of its own. Daisy is called a *composite* flower because it is *composed* of many smaller flowers.

Daisy seeds can stay *dormant* in the soil for a few years, waiting for just the right time to sprout.

Their stems are hard and wiry. Their leaves are dark green on both sides and rather smooth.

Daisy plants are polite to one another. They give each other room to grow. Find some daisies or plant them in your garden and you will see how *gracious* they are.

Daisy Fairies

While ballet dancing
in thin air,
We *pirouette*
without
a care.

The sun is warm
The day is fair
And there is lots
Of space to share.

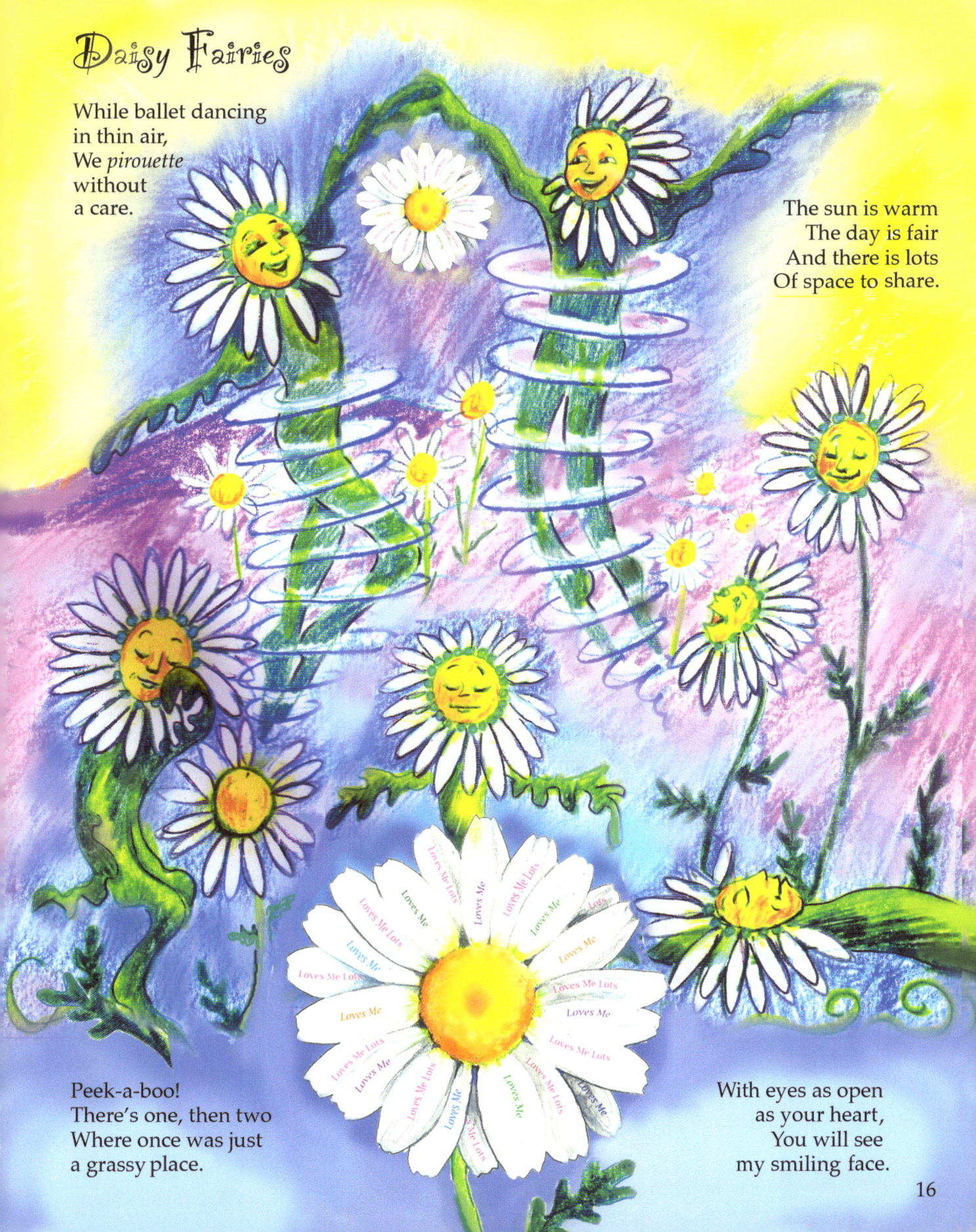

Peek-a-boo!
There's one, then two
Where once was just
a grassy place.

With eyes as open
as your heart,
You will see
my smiling face.

Plantain
Fact and Folklore

Plantain seeds are often found mixed in with different kinds of grains. In this clever way, they have spread themselves all over the world.

Plantain came to North America with the English colonists. There was so much plantain growing on the damaged land around colonial settlements that Native Americans called it, "White Man's Foot."

When plantain seeds are wet, they develop a gummy, gluey coating that causes them to stick to soil particles and animals. This trick also helps them to spread.

Birds are fond of plantain seeds which are grown and added to some bird seed mixtures. Plantain seeds contain more oil than many other types of seeds.

Plantain has been used in protection spells for houses and cars. It is also said to protect travelers.

Plantain was also called "Soldier's Herb." Like yarrow, it is used to treat wounds.

Plantain

Chapter Five

Plantago major
"large plantain"

Plantago lanceolata
"lance-leaf plantain"

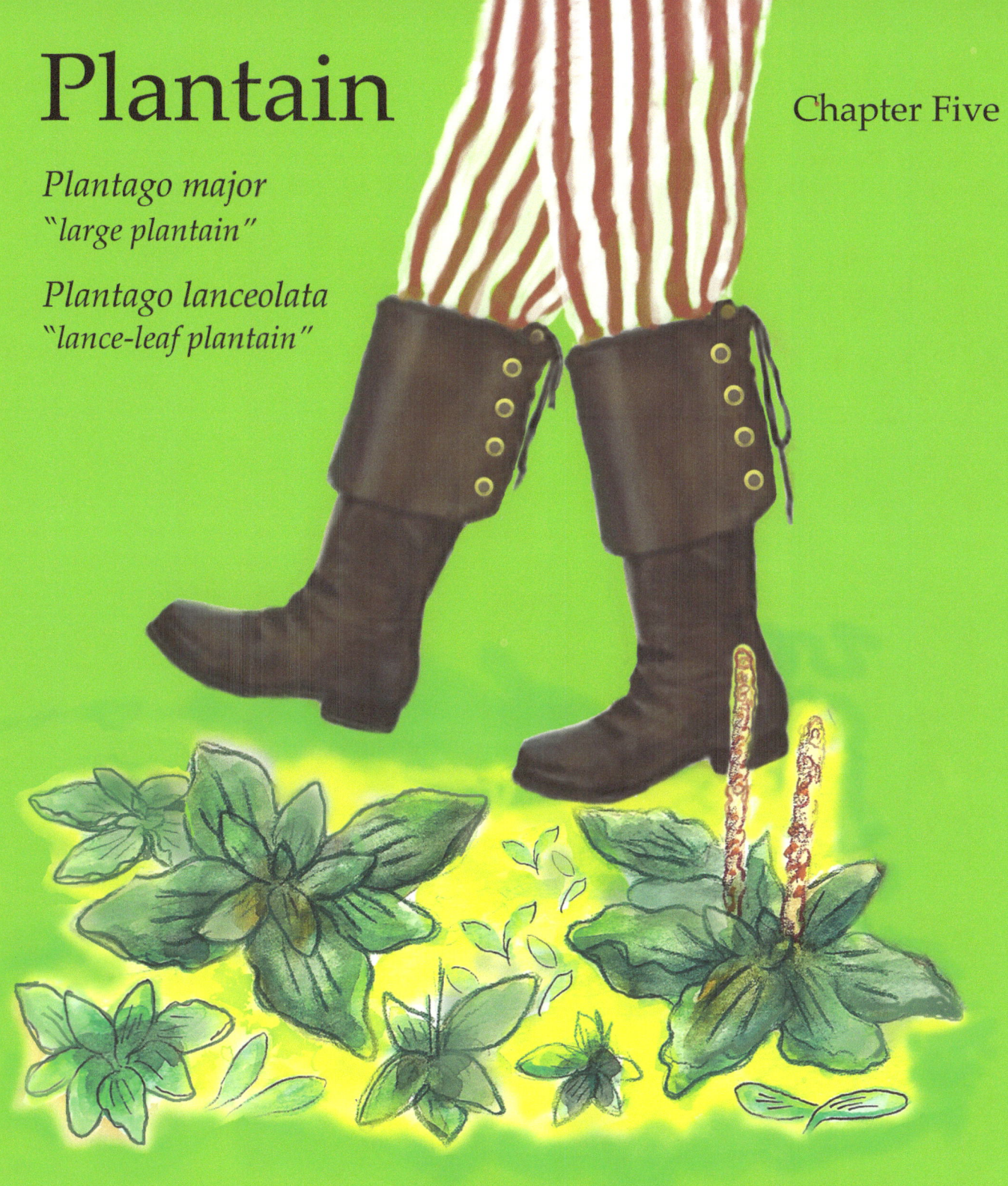

Nicknames: *Braids, Dooryard plant, White-Man's-Foot, Waybread, Ribwort, Ripple Grass, Fleaseed*

Plantain Plantago major Dooryard Plant

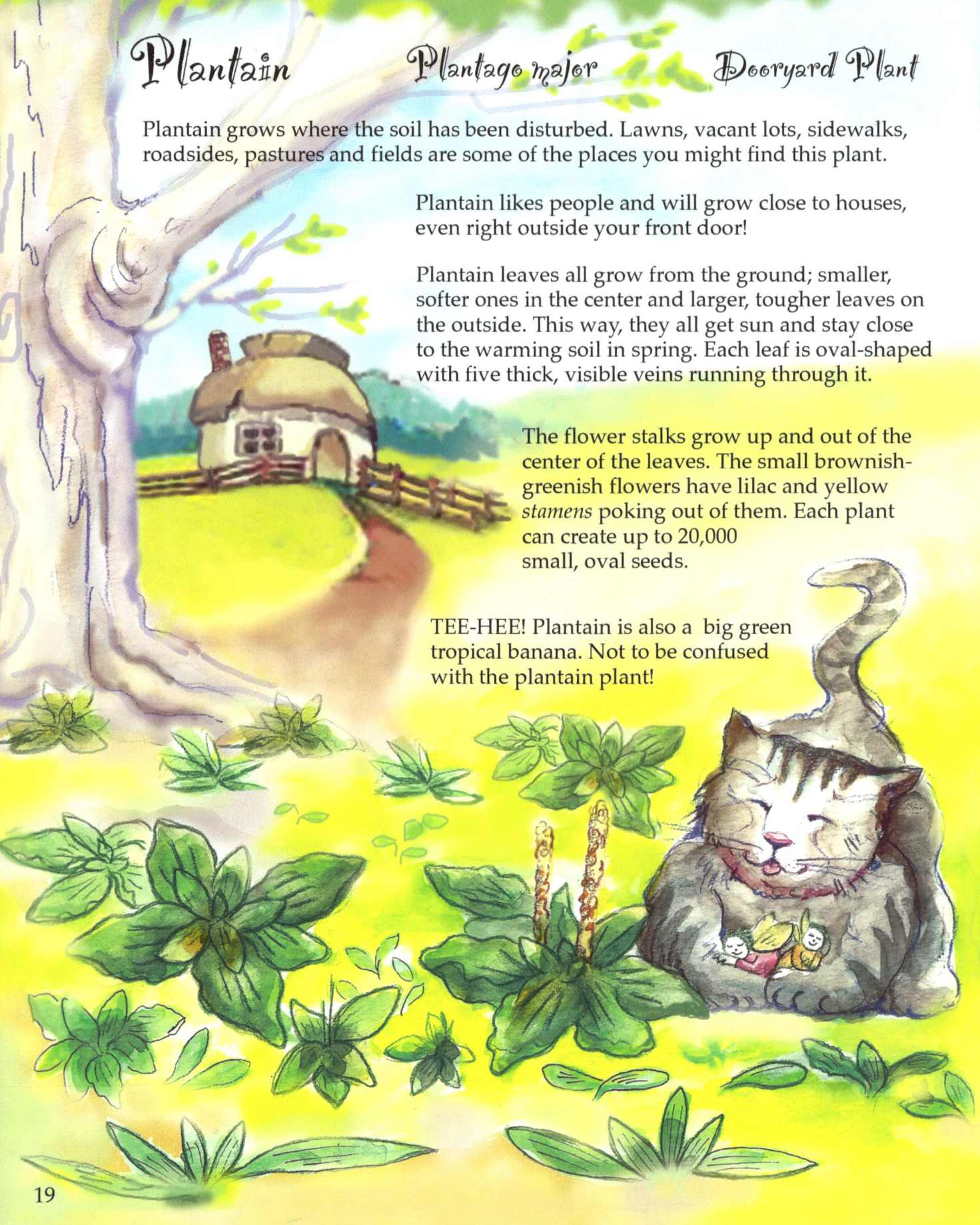

Plantain grows where the soil has been disturbed. Lawns, vacant lots, sidewalks, roadsides, pastures and fields are some of the places you might find this plant.

Plantain likes people and will grow close to houses, even right outside your front door!

Plantain leaves all grow from the ground; smaller, softer ones in the center and larger, tougher leaves on the outside. This way, they all get sun and stay close to the warming soil in spring. Each leaf is oval-shaped with five thick, visible veins running through it.

The flower stalks grow up and out of the center of the leaves. The small brownish-greenish flowers have lilac and yellow *stamens* poking out of them. Each plant can create up to 20,000 small, oval seeds.

TEE-HEE! Plantain is also a big green tropical banana. Not to be confused with the plantain plant!

Plantain Fairies

We have such big families,
Too many kin to count.
Good thing we like each other
In immeasurable amounts.

How to share this tiny place?
It isn't such a riddle.
Grown-ups on the outside leaves
And babies in the middle.

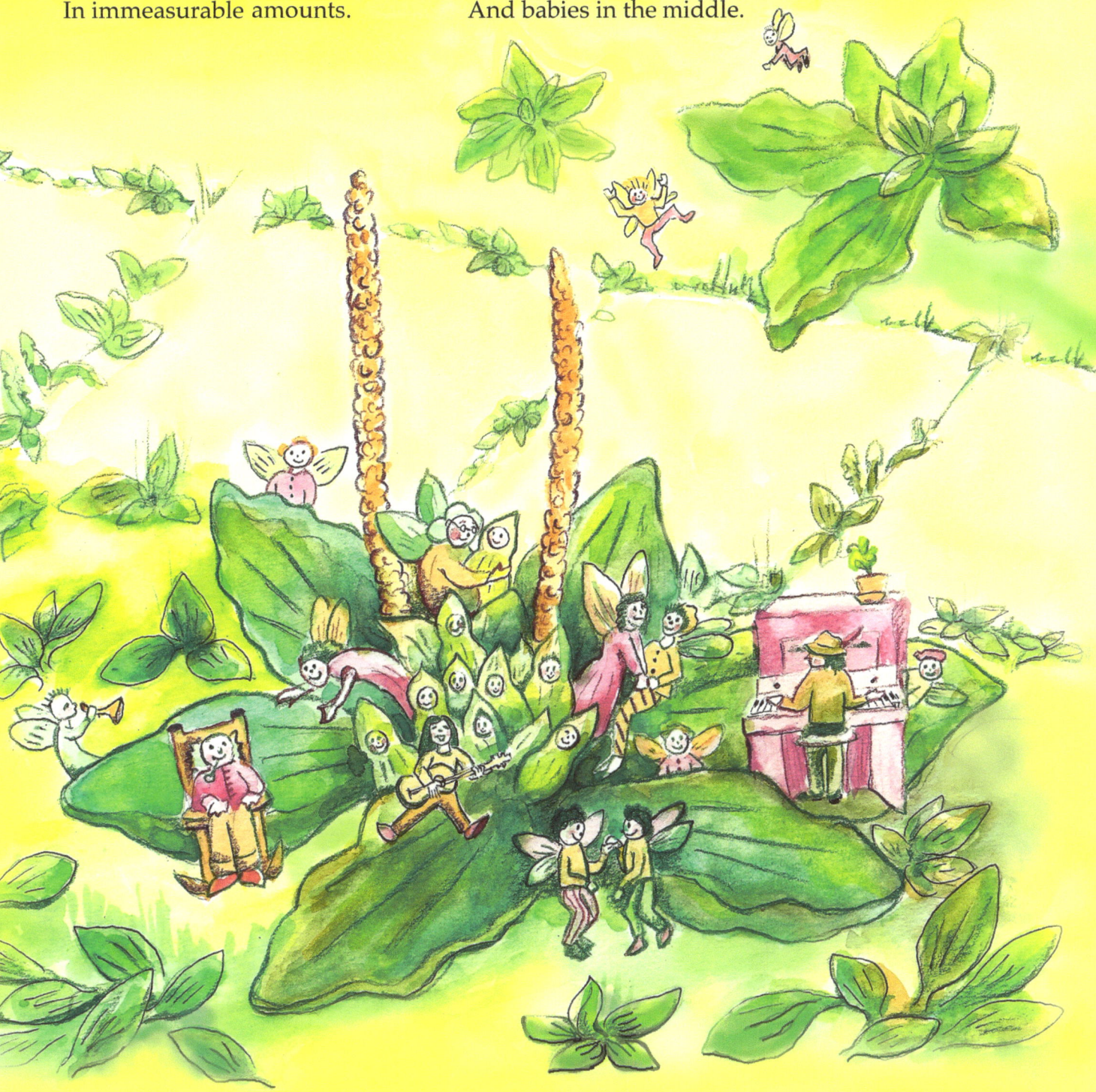

Lots of entertainment here, and all of it for free.
Next time you're in town, please stop in for a jamboree!

Yarrow
Fact and Folklore

White yarrow flowers are magical in love charms. A small *sachet* full of yarrow can be placed under one's pillow for clear dreams.

Some people still use dried yarrow stems to tell fortunes. They read from an ancient book called "The I-Ching" or "Book of Changes."

The *Druids* used stems of yarrow to forecast the weather.

In Greek mythology, *Achilles* was a hero of the Trojan War. *Achilles* used yarrow on the battlefield to stop wounded soldiers from bleeding. Yarrow was known then as *Herbal militaris*.

Here is a Gaelic charm that was recited when picking yarrow:

*"I will pluck the smooth yarrow that my figure may be sweeter, that my lips may be warmer, that my voice may be gladder.
May my voice be like a sunbeam.
May my lips be like the juice of the strawberry."*

Yarrow

Chapter Six

Achillea millefolium
"*a thousand leaves of Achilles*"

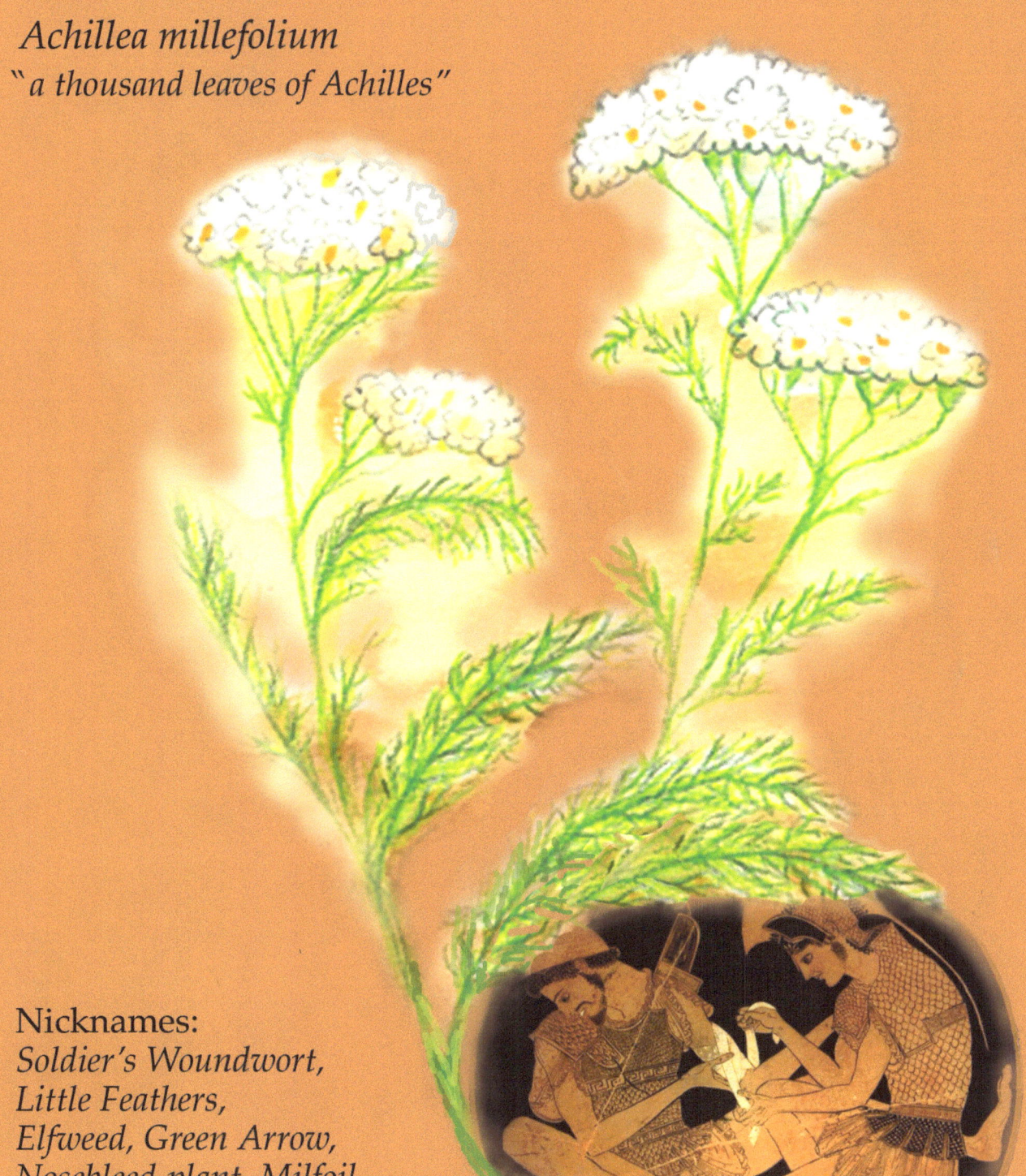

"*Achilles healing a soldier's wound*"
A picture from an ancient Greek platter

Nicknames:
*Soldier's Woundwort,
Little Feathers,
Elfweed, Green Arrow,
Nosebleed-plant, Milfoil,
Gordaldo, Thousand-leaf
Old man's pepper*

Yarrow *Achillea millefolium* Elfweed

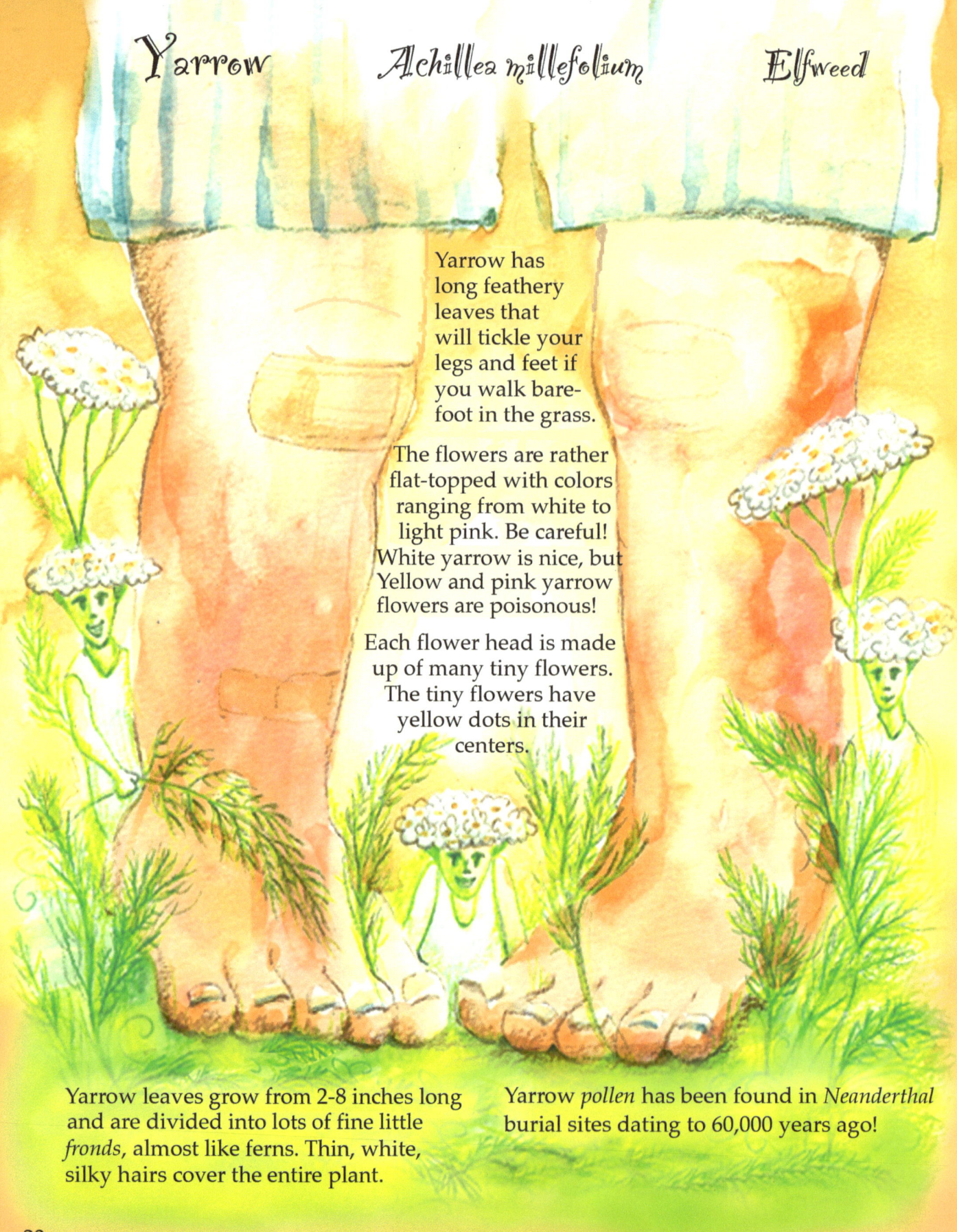

Yarrow has long feathery leaves that will tickle your legs and feet if you walk barefoot in the grass.

The flowers are rather flat-topped with colors ranging from white to light pink. Be careful! White yarrow is nice, but Yellow and pink yarrow flowers are poisonous!

Each flower head is made up of many tiny flowers. The tiny flowers have yellow dots in their centers.

Yarrow leaves grow from 2-8 inches long and are divided into lots of fine little *fronds*, almost like ferns. Thin, white, silky hairs cover the entire plant.

Yarrow *pollen* has been found in *Neanderthal* burial sites dating to 60,000 years ago!

Yarrow Fortune Fairies

We are ever clever thinkers, long and slender, strong of will.
We are always keeping busy, even when we're holding still.

For we send thoughts of healing that can travel over miles.
With sympathy and feeling that will surely bring you smiles.

When you see us sometimes telling fortunes to a friend,
Be certain it is always for a healthy, happy end.

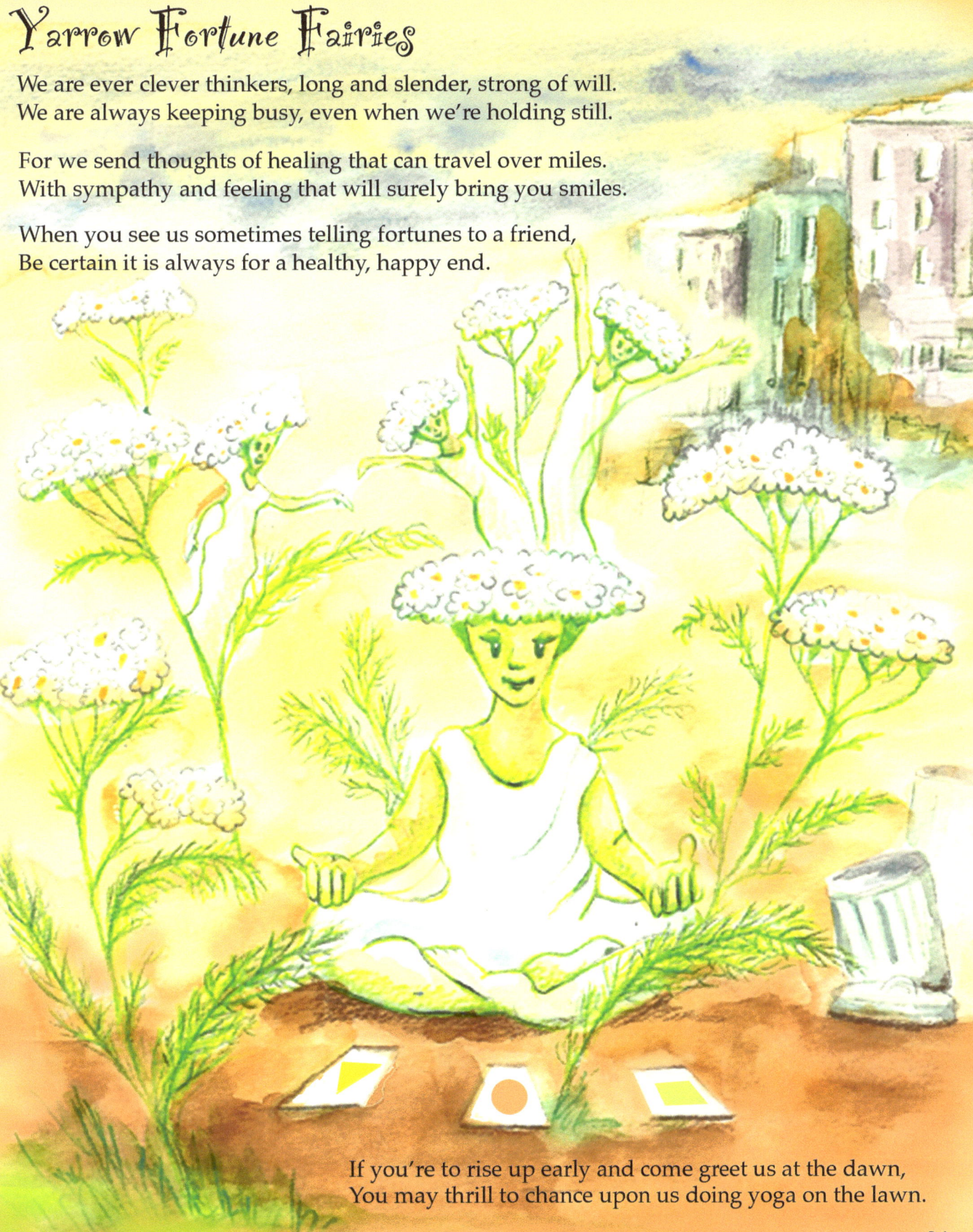

If you're to rise up early and come greet us at the dawn,
You may thrill to chance upon us doing yoga on the lawn.

Saint Johnswort Fact & Folklore

Summer solstice is the longest day of the year. It is one of the best times to gather flowers like St. Johnswort in full bloom. In Old Europe, solstice day was also called "Saint John's Day."

Saint John was an apostle from the Bible. This plant may have been named after him. Other people think it might be named after the brave and faithful patron saint of France, Joan of Arc. They call this plant "Saint Joanswort" after her.

People hung this plant over religious symbols and pictures of saints to keep evil out of their homes.

The juice of a St. Johnswort flower, rubbed on a front door, will keep a house from harm.

St. Johnswort doth charm all the wicked away
If gathered at noontime, the Saint's holy day
Devils, they have not the power to harm
Those people who gather
the plant for a charm

old english rhyme

Saint Johnswort

Chapter 7

Hypericum perforatum

*"leaf with lots of holes
 hung above a picture"*

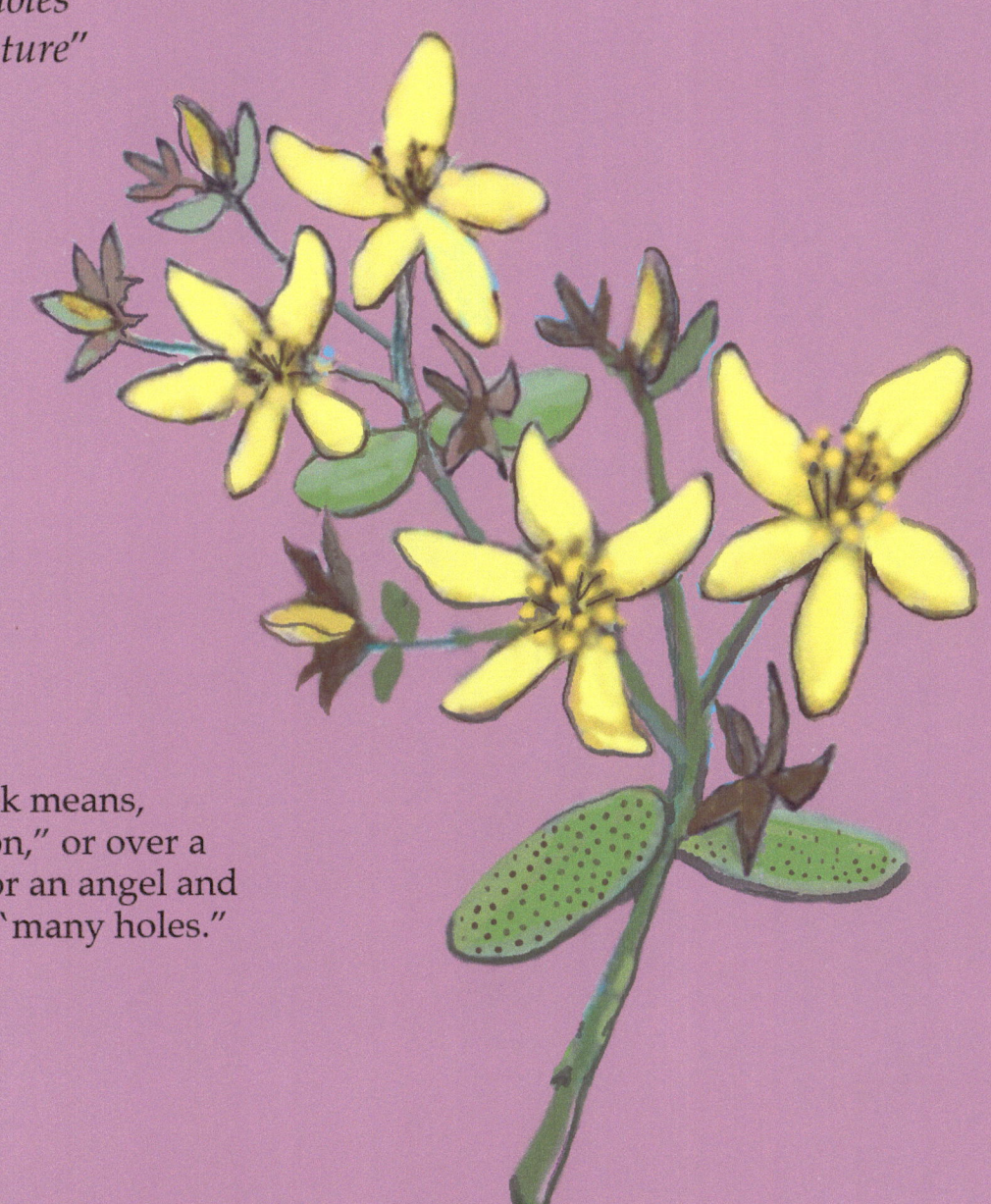

Hypericum in Greek means, "over an apparition," or over a picture of a saint or an angel and *perforatum* means "many holes."

Nicknames: *Tipton's Weed, Saint Joanswort, Rosin Rose, Chase-devil, Goatweed, Klamath Weed*

Saint Johnswort *Hypericum perforatum* Rosin Rose

Cheerful Saint Johnswort grows wild in many meadows around the world. The bright yellow flowers seem to shout, "Hello, hello, hello!"

Each sunlight-loving flower has five petals. The flowers bloom late spring to mid-summer. Many delicate *stamens*, in bundles, radiate from the center of the flowers. The stamens are tipped with orangey-yellow pollen.

Saint Johnswort leaves are oval shaped with smooth edges. They grow opposite each other on straight, branched stems. When you hold a leaf up to the light, you will see that it seems to be pierced full of tiny holes, as if by an invisible needle. These holes are really small plant glands that contain a reddish-purple oil.

The flower buds and seed pods are also full of reddish-purple oil. If you crush one of them between your fingers, they will be stained a rich red color.

Underneath the petals are pointed *sepals* which also have an interesting reddish-purplish hue.

St. is short for street and it is also short for Saint.

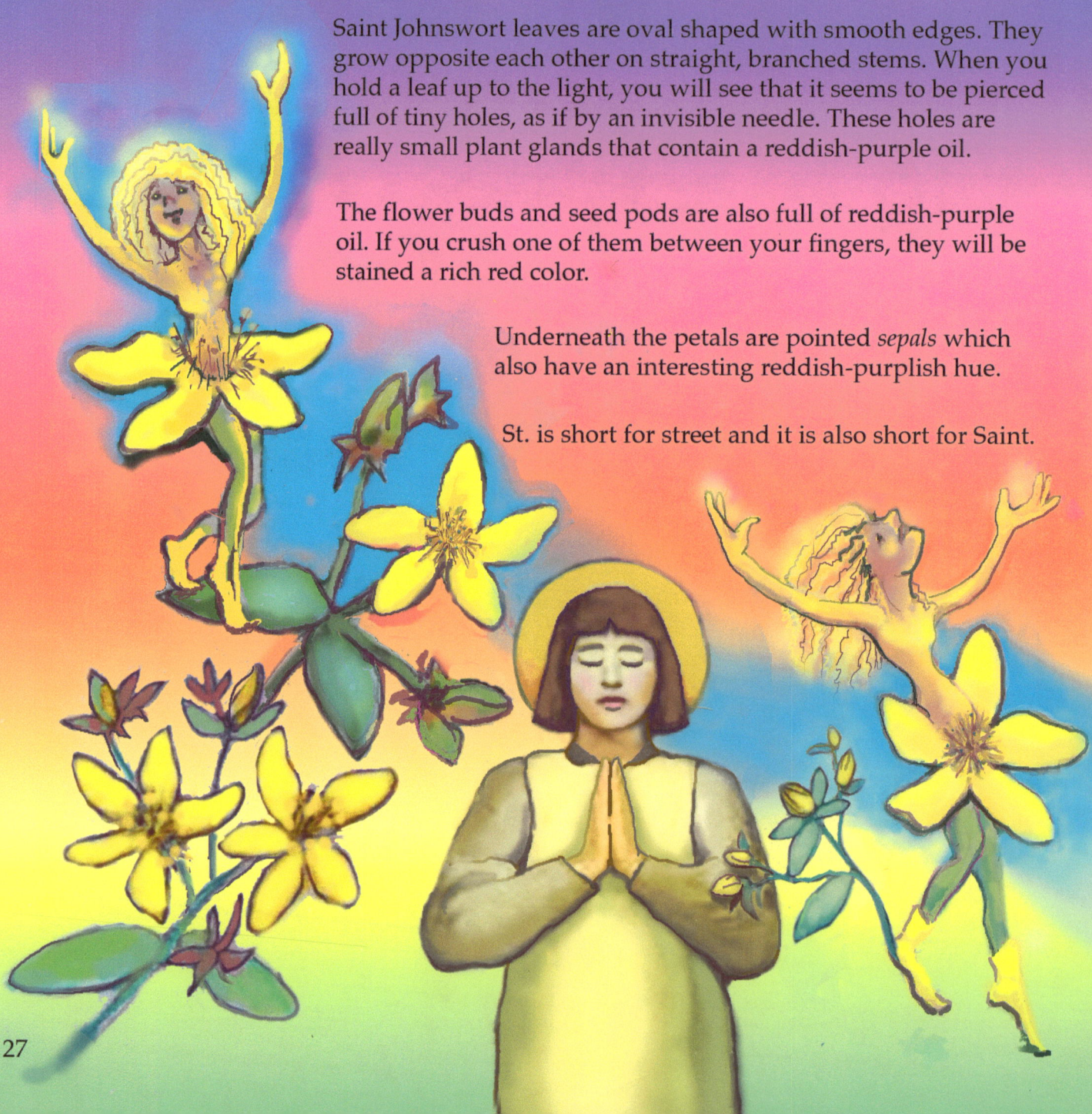

Saint Johnswort Fairies

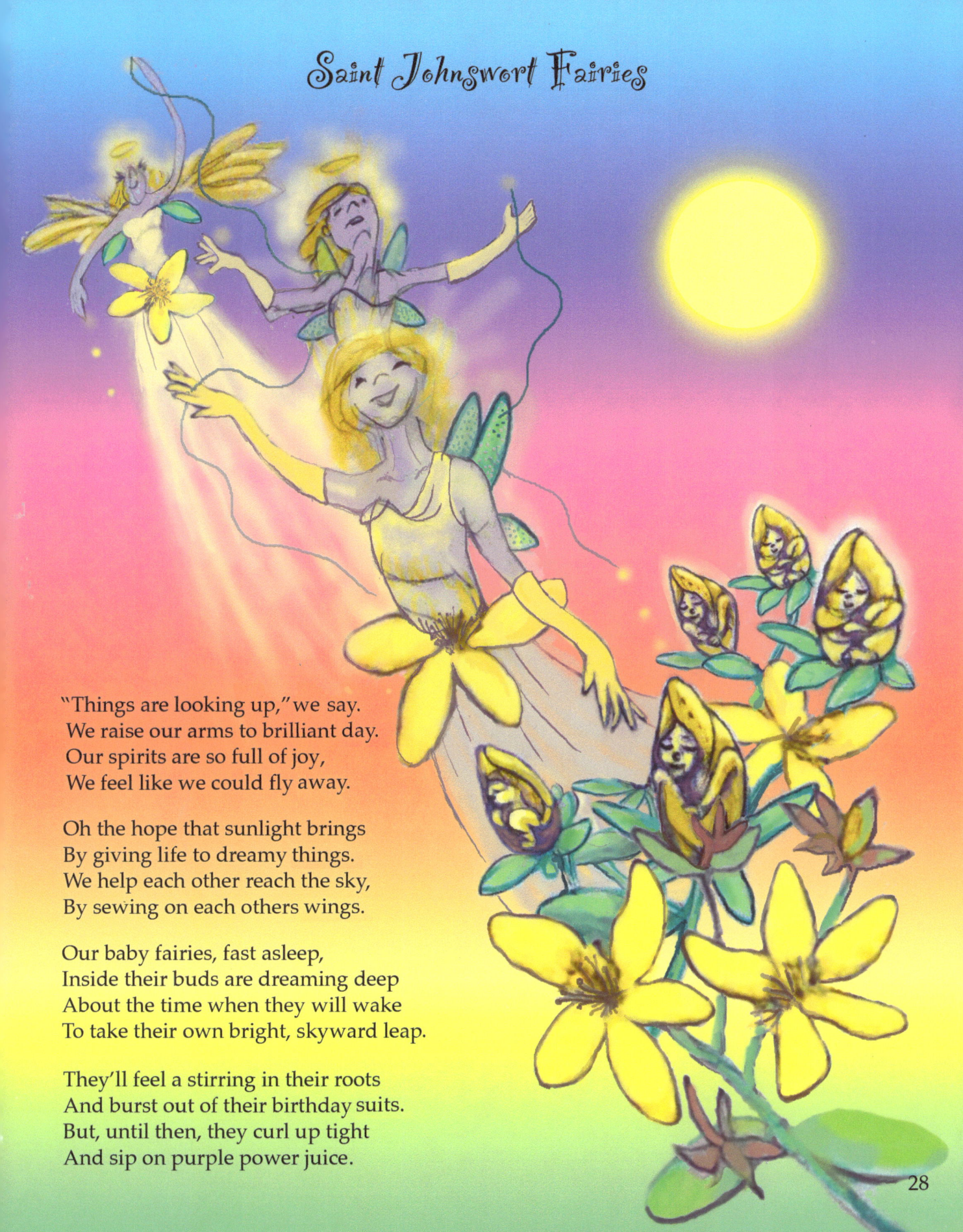

"Things are looking up," we say.
We raise our arms to brilliant day.
Our spirits are so full of joy,
We feel like we could fly away.

Oh the hope that sunlight brings
By giving life to dreamy things.
We help each other reach the sky,
By sewing on each others wings.

Our baby fairies, fast asleep,
Inside their buds are dreaming deep
About the time when they will wake
To take their own bright, skyward leap.

They'll feel a stirring in their roots
And burst out of their birthday suits.
But, until then, they curl up tight
And sip on purple power juice.

Nettle Fact and Folklore

Fiber can be made from nettle roots and stems. Clothing, paper, and even sheets can be woven from nettle fiber.

Archeologists have found ancient burial cloths woven out of nettle fibers.

In the Hans Christian Anderson fairy tale, "The Princess and the Eleven Swans," the princess wove her brother's coats from nettles.

A bright green or yellow dye can be made from nettle juice.

In Ireland, nettles grow wherever elves live and they protect people from harm. You can call on nettle when you feel unsafe or unsure.

If cows are fed wilted nettles, they can not be hexed.

"Be Nice to Nettles Week," is promoted by CONE, an environmental group in the United Kingdom.

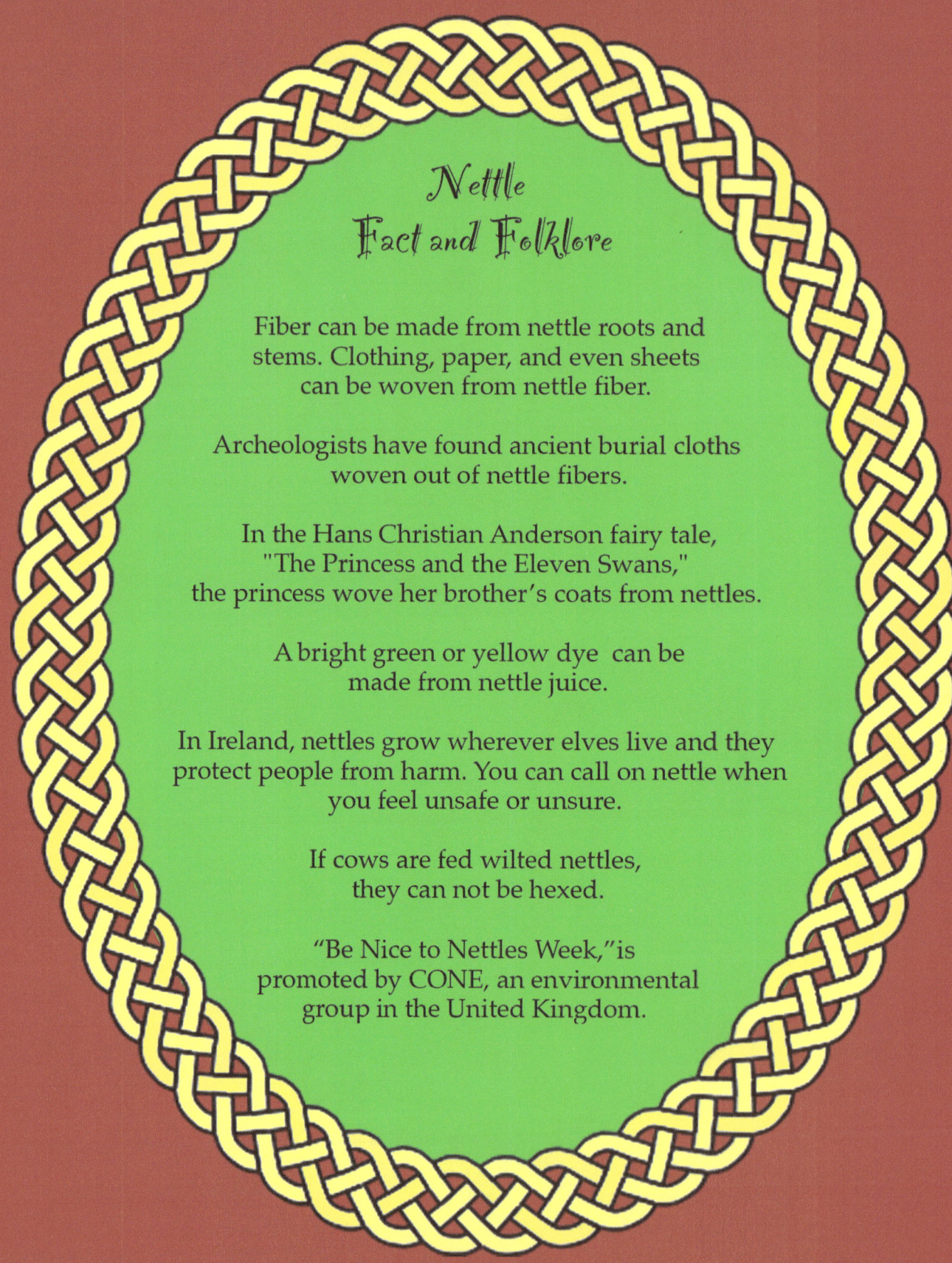

Nettles

Chapter Eight

Urtica dioica
"a sting from two houses"

Nicknames: *Bull Nettle, Stinging Nettle, Net Plant, Devil's Leaf, Common Nettle*

Nettle means to tie or bind.

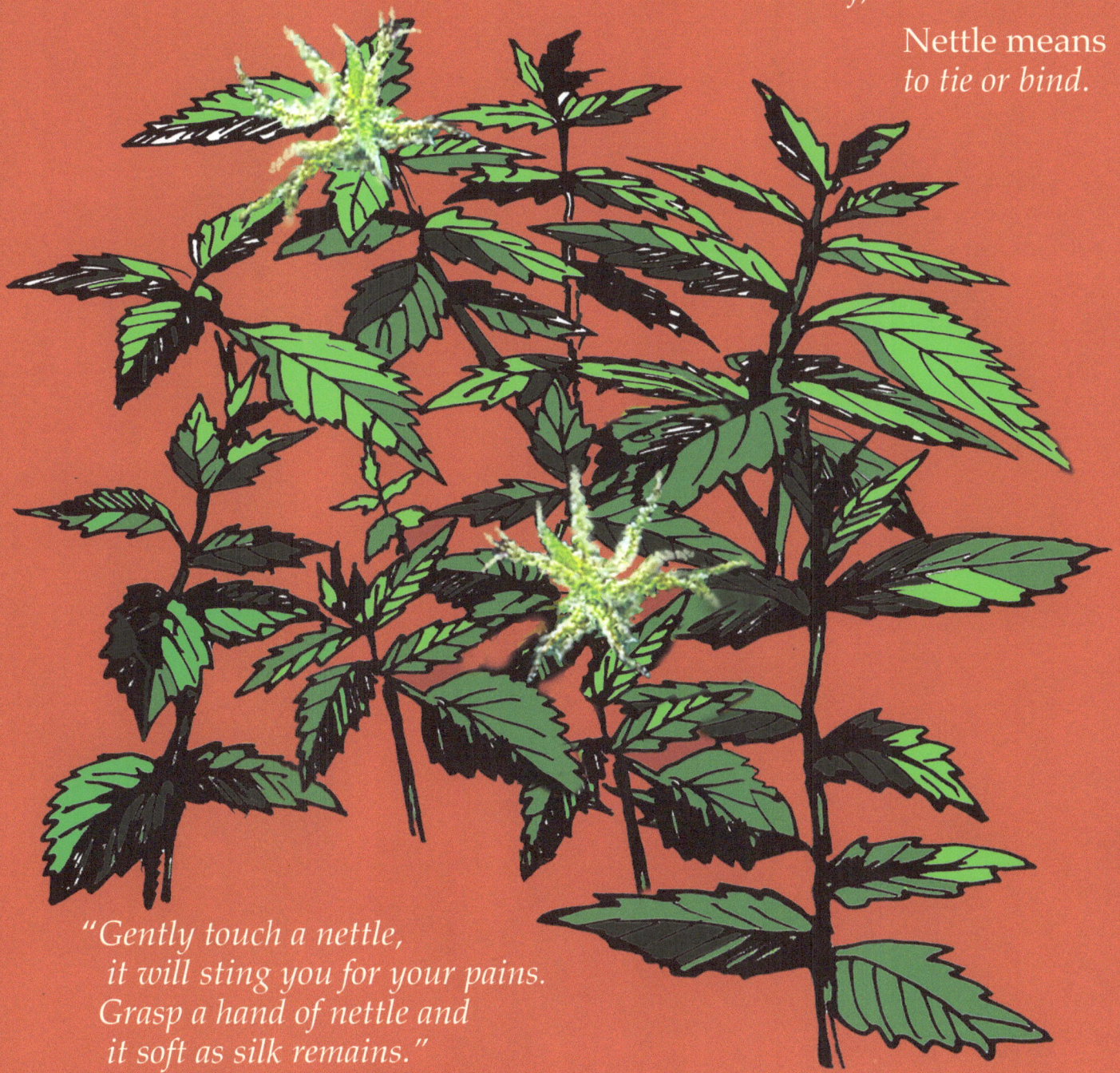

*"Gently touch a nettle,
 it will sting you for your pains.
 Grasp a hand of nettle and
 it soft as silk remains."*

Lynne-sanders Braithwaite

Nettles Urtica dioica Stinging Nettles!

Look out for stinging nettles! The plant is covered in fine downy hairs that can sting bare skin when you brush by. The hollow stinging hairs contain formic acid. When the acid is released, it causes a stinging feeling. Nettles has a way of getting our attention and helping us to stay alert. The plant often grows in areas where the soil has been depleted or disturbed. One purpose of nettles is to protect the land while the land recovers.

Stinging nettles have deep green, finely toothed, long, heart-shaped leaves that grow opposite each other on strong, square stems. Long, furry clusters of greenish-yellow flowers bloom from June through September. Each nettle plant has either male or female flowers, and some nettle plants contain both male and female flowers. Thusly, the saying, *"from two houses."*

When stinging nettle is dried or cooked, the sting vanishes!

Another name for Daddy Longlegs is "Jenny Nettles."

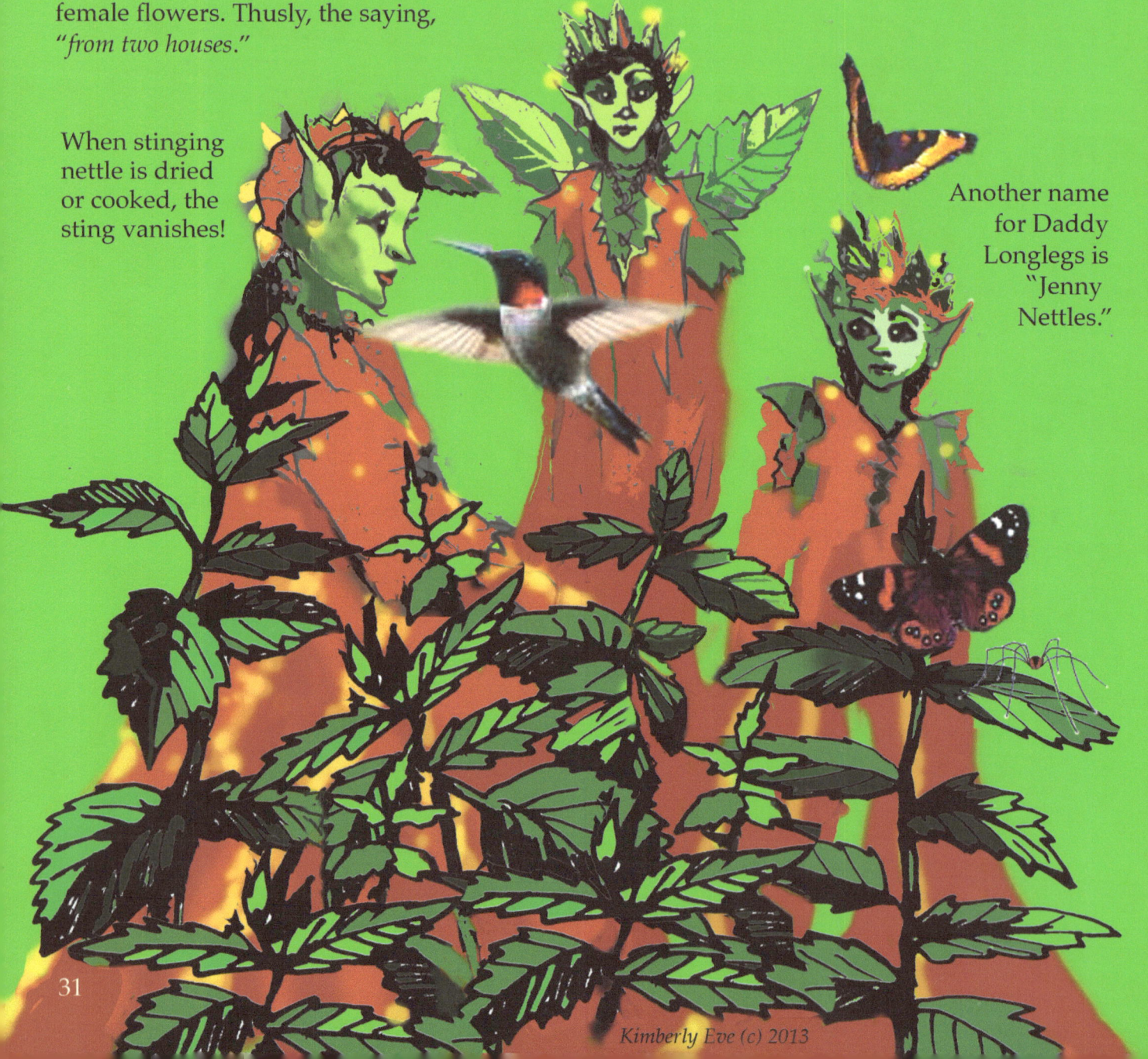

Kimberly Eve (c) 2013

Nettle Fairies

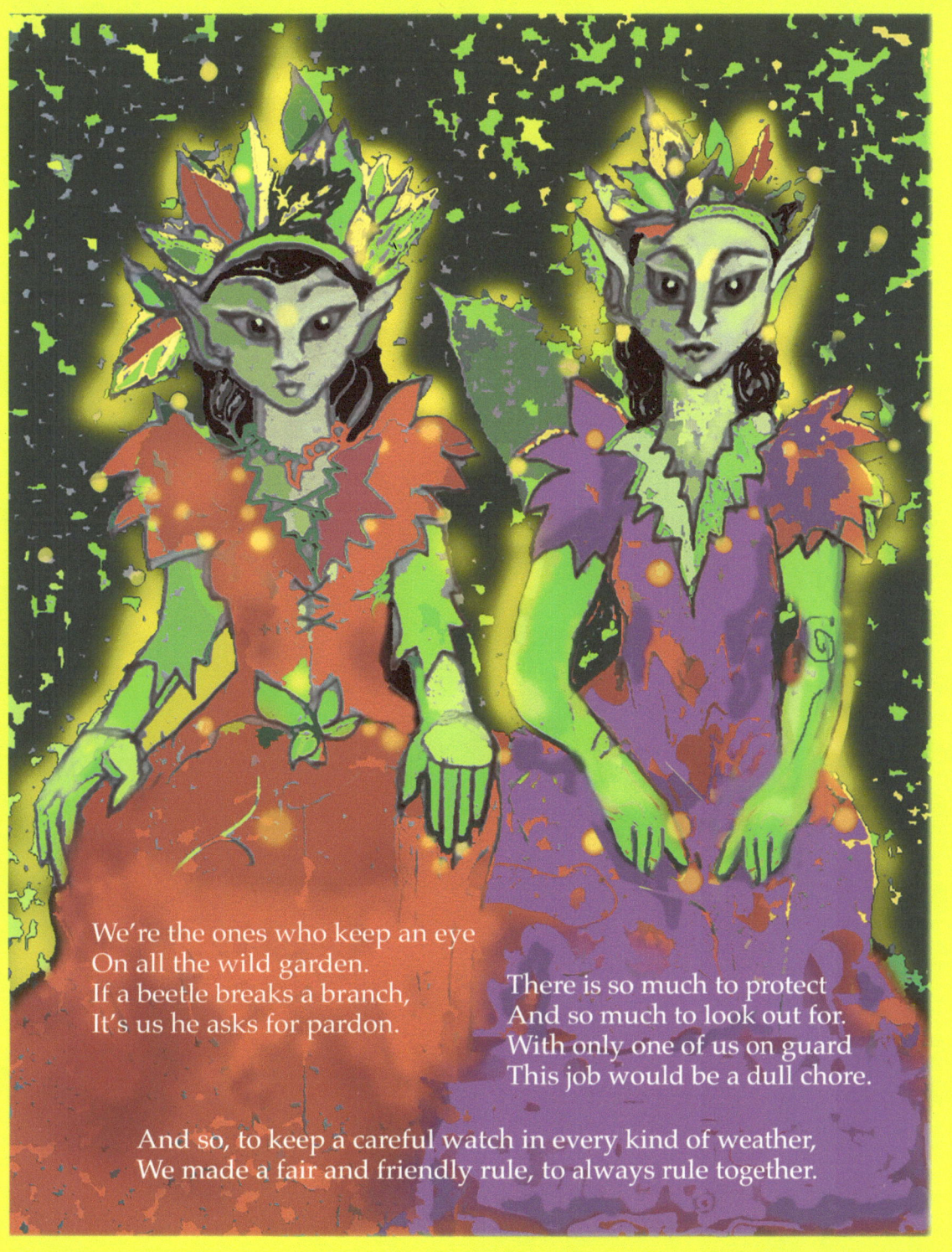

We're the ones who keep an eye
On all the wild garden.
If a beetle breaks a branch,
It's us he asks for pardon.

There is so much to protect
And so much to look out for.
With only one of us on guard
This job would be a dull chore.

And so, to keep a careful watch in every kind of weather,
We made a fair and friendly rule, to always rule together.

Glossary

adaptable: able to fit in and adjust to many different situations
basal rosette: a cluster of leaves in crowded spirals near the ground
chevron: a "V" shape
composite, composed: made of two or more parts
cultivate: to prepare the soil for plants, to nurture the growth of plants
dormant: resting as if asleep
Druid: an ancient magician or wizard
globe: ball or sphere
erosion: the slow wearing away of soil, rock or other material
floret: a small flower
frond: a feathery leaf
Gaelic: an old Irish or Scottish language
gracious: pleasantly kind
hexagram: a six sided star shape
indigenous: native
individual: singular, one
intertwine: wind together
jagged: rough, uneven
kindred: related, similar, a relative
leaflets: small leaves
myth: a traditional, made-up story
Neanderthal: the time of cavemen (and women)
pirouette: a quick spin around
pistil: The part of the flower that bears the stigma
pollen: a fine dust made of plant spores
rosette; a cluster of leaves in crowded spirals
sachet: a small bag of scented powder or dried plants
savor: to taste slowly, usually with joy and pleasure
sepal: a small leaf under a flower that often looks like a petal
species: a group of living things that share common traits
stalk: stem
stamen: the part of the plant that makes pollen
stigma or **stylus**: the part of the plant that holds pollen
symbol: a sign or token that stands for something else
Victorian era: during Queen Victoria's reign 1819-1901
wort: plant or weed
whorl: a spiraling circle

The big, green world of wild plants is yours to get to know!

Weeds return year after year like good old friends. They seed themselves and grow without cultivation. No one needs to plant, fertilize, weed or water weeds! Welcome weeds!

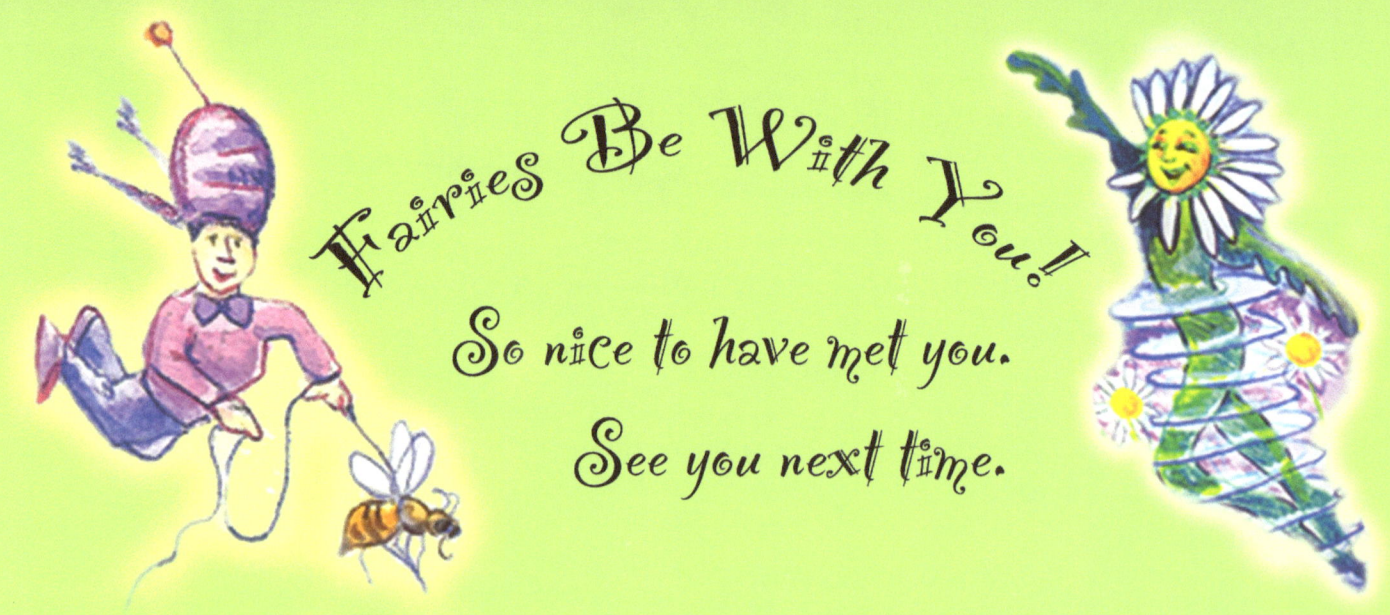

Fairies Be With You!
So nice to have met you.
See you next time.

Selected Bibliography

Susun Weed (1989) Healing Wise, Ash Tree Publishing, Woodstock, NY
Juliette de Bairacli Levy (1997) Common Herbs for Natural Health, Ash Tree publishing, NY
Maida Silverman (1997) A City Herbal, Ash Tree Publishing, Woodstock, NY
Michael Tierra (1998) The Way of Herbs, Pocket Books, New York, NY
Rosemary Gladstar (2008) Herbal Recipes for Vibrant Health, Storey Publishing, MA
Demetria Clark (2011) Herbal Healing for Children, Healthy Living, Summertown, TN
Leslie Tierra (2005) A Kids Herbal Book, Robert Reed Publishing, Bandon, OR

Kimberly Eve, aka Jaia Wise, is a many-times published illustrator through Ash Tree Publishing in Woodstock, New York and Inner Traditions in Rochester, Vermont. During her time at Ash Tree, she had the honor of helping to bring back in to print many books of the famed herbalist, Juliette de Bairacli Levy. Kimberly designed cover and interior illustrations for those books and began work on "Welcome Weeds!" while apprenticing with the herbalist/author Susun Weed. Kimberly attended the School of Visual Arts in New York City where she focused on animation and illustration. She has studied and worked with wild plants for over twenty years. This is her first children's book with more to come. She lives seasonally on Cape Cod where, happily, all of the plants in this book flourish.
To view more of her artwork please go to...
www.kimberlyeve.com and
www.welcomeweeds.com

www.ingramcontent.com/pod-product-compliance
Lightning Source LLC
Chambersburg PA
CBHW050353180526
45159CB00005B/2004